AMOK BOOKS
Kaleidoscopic Creatures BOOK 2

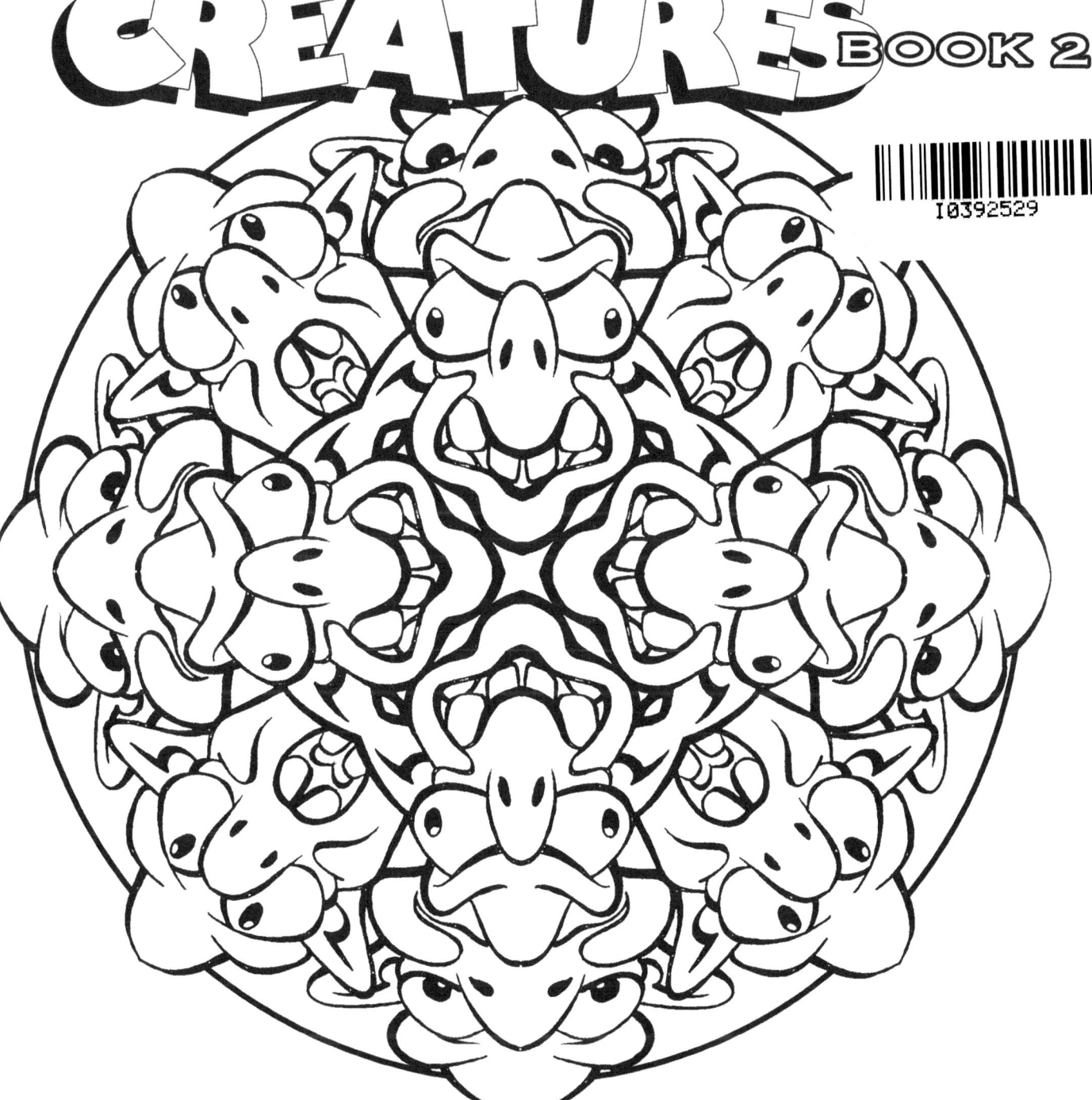

Dave Weiss
AMOKBOOKS, MOHRSVILLE, PA
DWEISSCREATIVE.COM

Why Kaleidoscopics?

Some people call them Mandalas, but I'm just not comfortable with that. Mandalas are sometimes associated with eastern religious rituals and that's not the direction I'm taking. To me these pieces are a departure from what I usually do. They are created in pieces and cut together into the images you see before you and while I have some idea what the final piece will look like, it is often a very pleasant surprise. It's as if the piece is seen through that favorite childhood toy, a kaleidoscope.

Why Creatures?

I have always loved to draw creatures, from my earliest childhood, to my time freelancing for a licensee of the *Teenage Mutant Ninja Turtles*, to my days doing children's coloring books, to my web comic *Creacher*. The reasons are multiple. First of all, many of them do not exist in the real world, so I can literally create anything I want. Additionally, in cartooning there is often sensitivity. People are often sensitive to the way they are portrayed. Controversy can keep people from hearing your message. Creatures look like no one and, as a result, can speak to everyone. What's not to love?

I think of my work on these pages as a kind of artistic jam session—giving my creativity wings and letting it soar. It is my hope that you, the colorist, will do the same. There is no right or wrong way to interpret these, only your way. Have fun with them. Get your materials out and let your creativity take flight. Whether you are coloring just to relax or you're trying to recapture your creativity, know this. You are creative and you are an artist. Pablo Picasso once said, "All children are artists, the problem is to remain one as one grows up."

Welcome back to art. The sky's the limit! Have fun!

© 2016 by David C Weiss

All rights reserved.
Published Mohrsville, Pennsylvania, by David C. Weiss for AMOK Books. AMOK Books, AMOKArts and A.M.O.K. Arts Ministry Outreach for the Kingdom are trademarks of David C. Weiss

Illustrations by David C. Weiss, AMOKArts.com

ISBN-13: 978-1535553261
ISBN-10: 153555326X

Library of Congress Cataloging-in Publication Data

Weiss, David C., 1963-
Kaleidoscopic Creatures: Book 2, 50 Images to Color by David C. Weiss

ISBN
1. Weiss, David C., 1963- 2. Art
3. Coloring

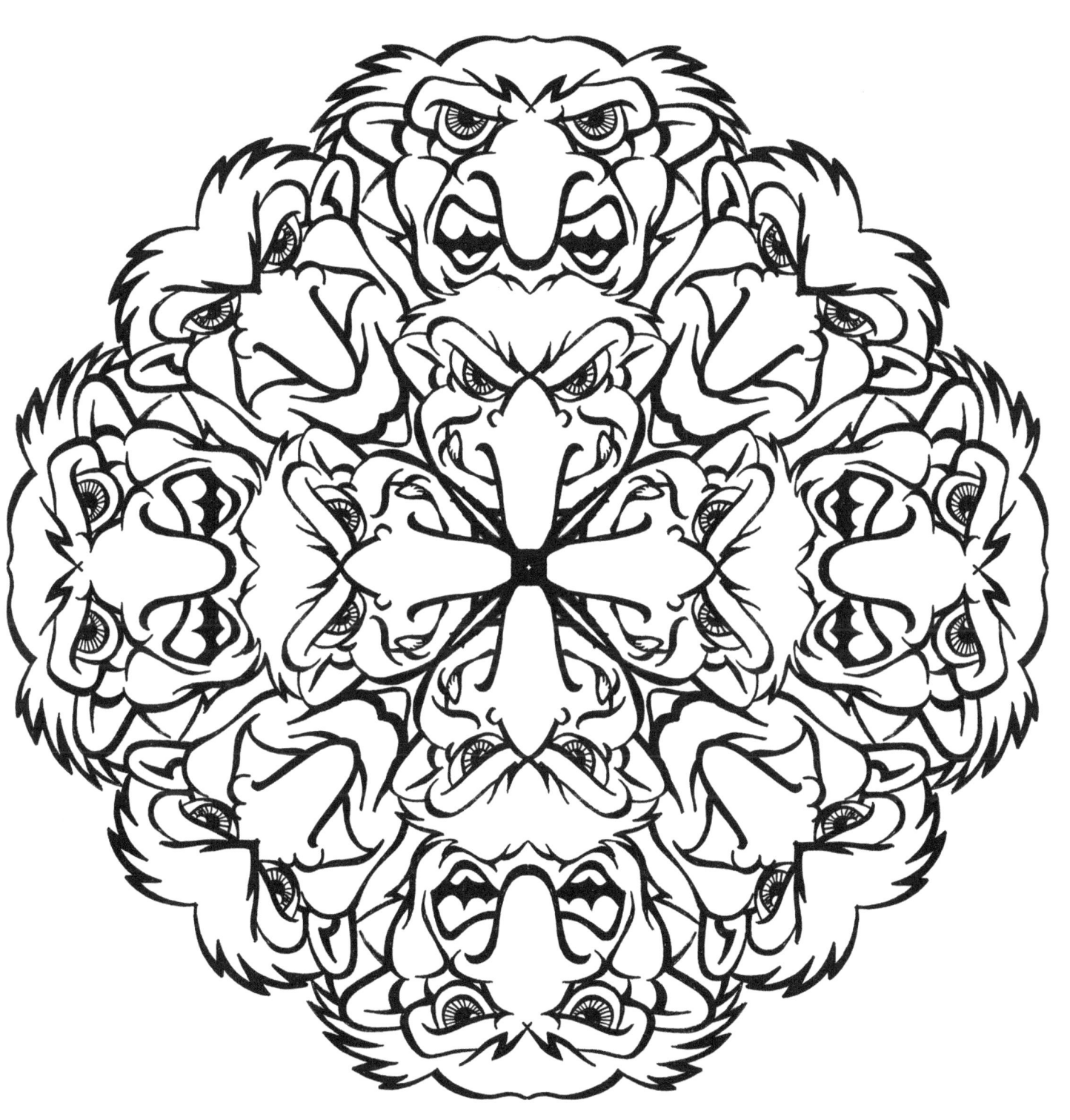

Kaleidoscopic Creatures Book 2
"Trolling"

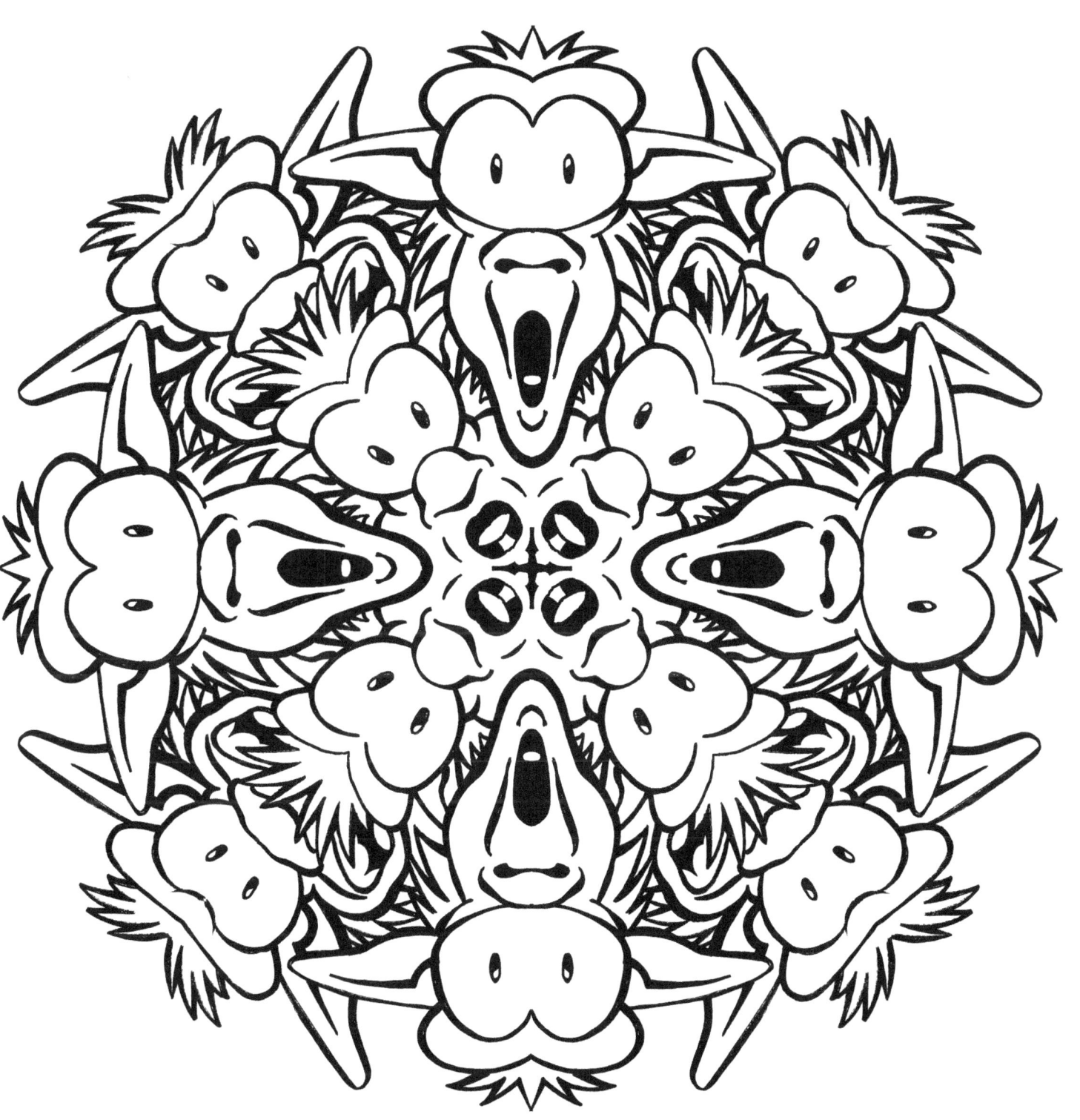

Kaleidoscopic Creatures Book 2
"Shock & Awwww"

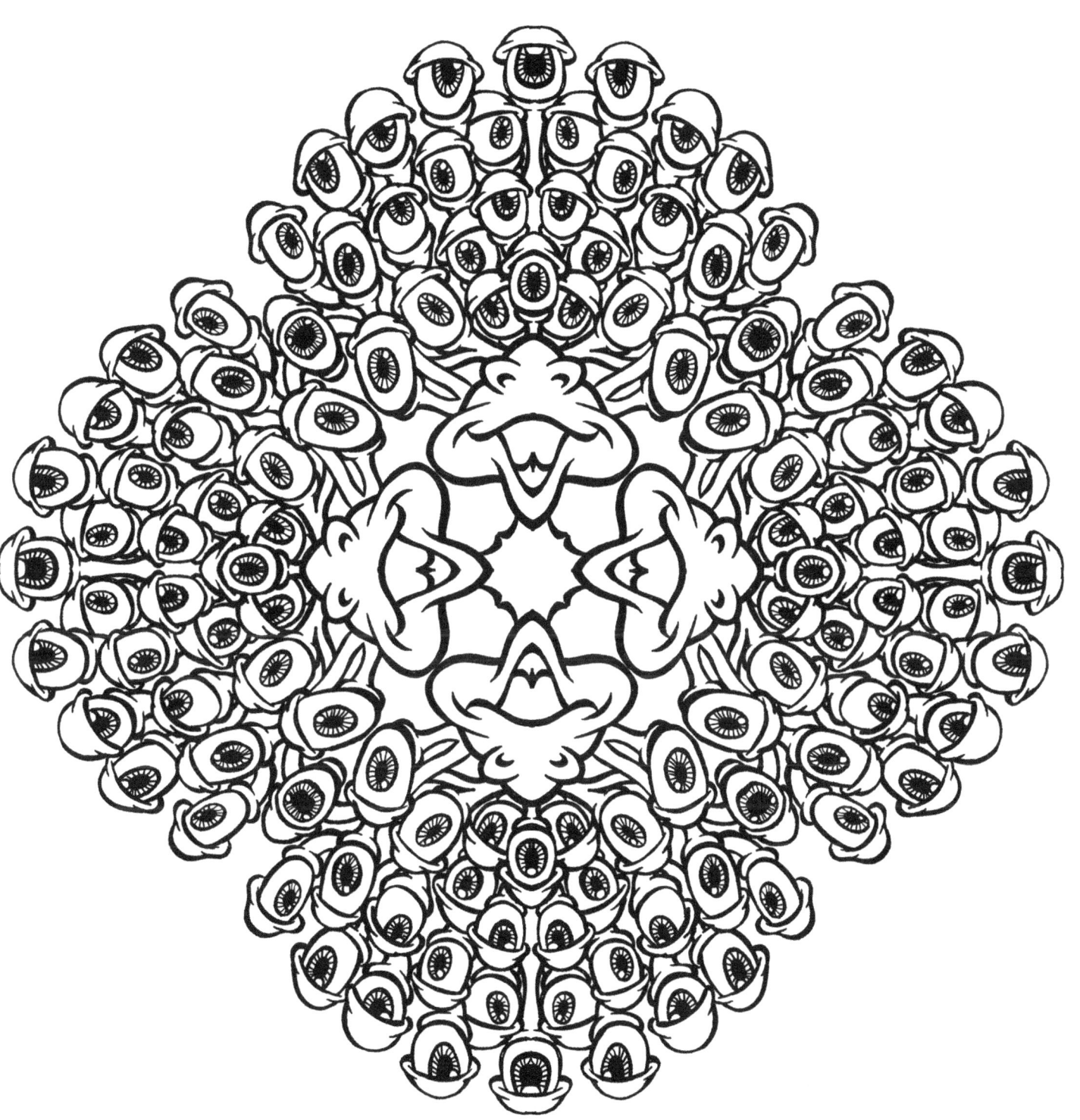

Kaleidoscopic Creatures Book 2
"The Eyes Have It"

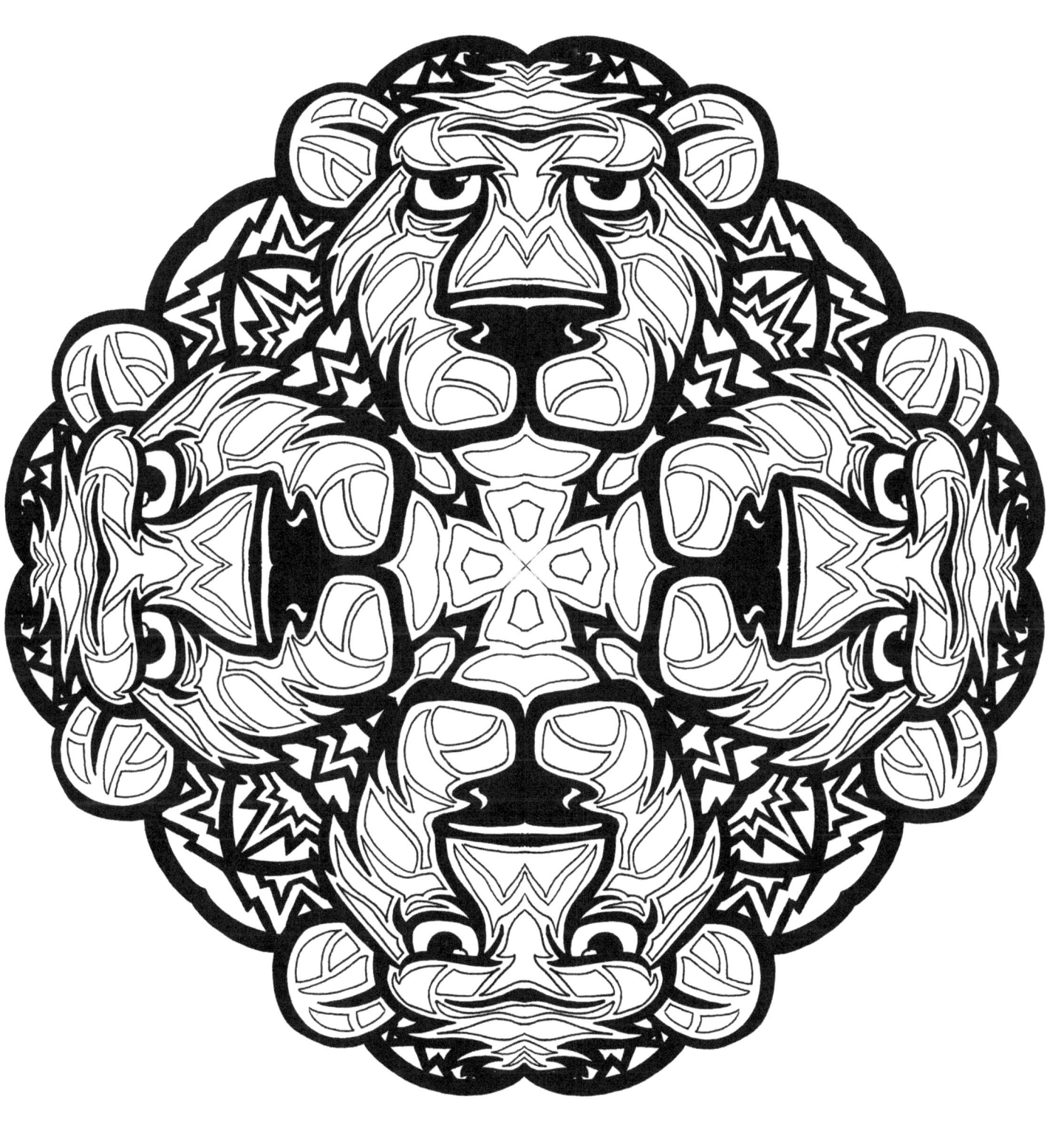

Kaleidoscopic Creatures Book 2
"Bear Market"

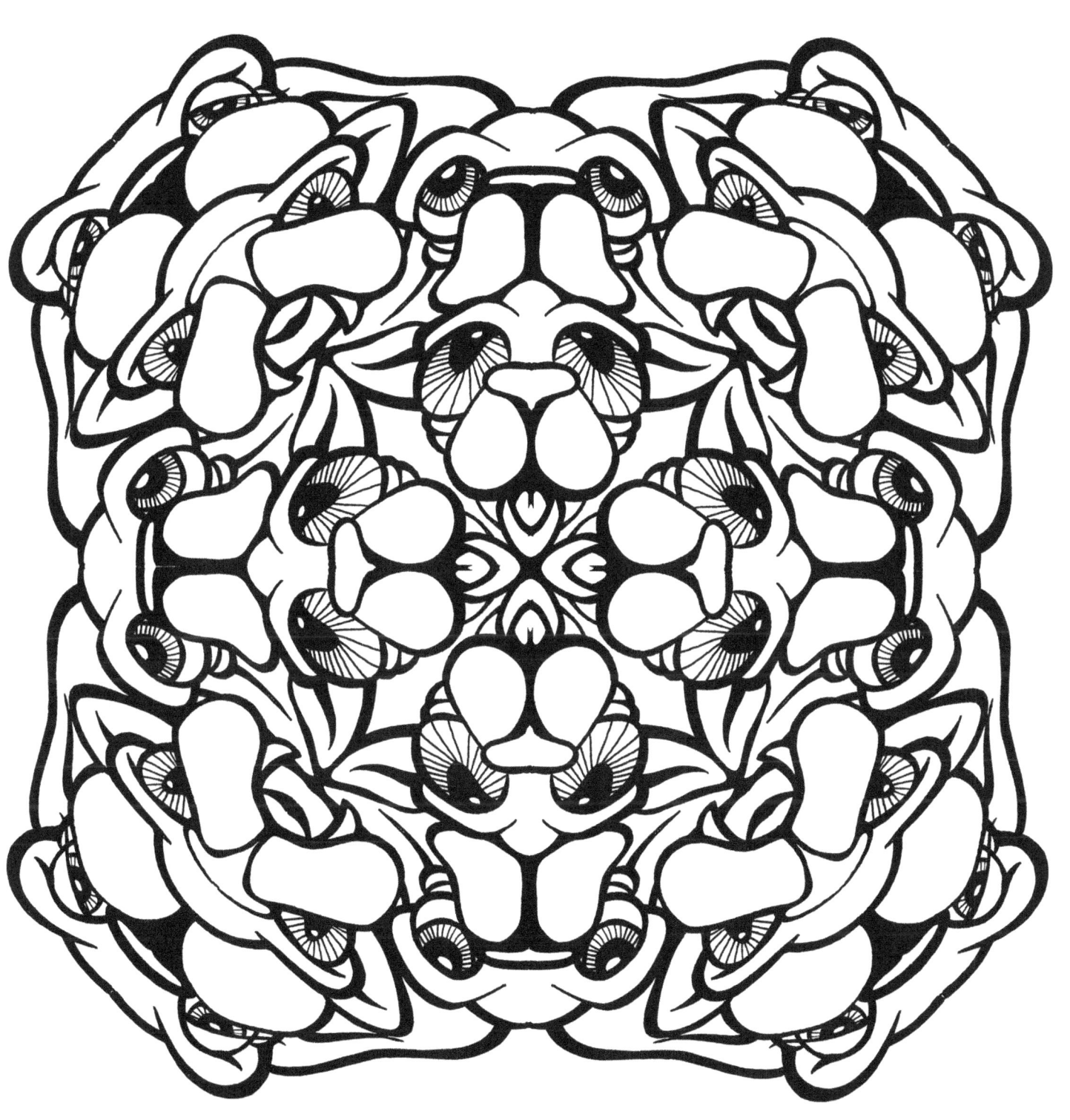

Kaleidoscopic Creatures Book 2
"Pet Shop Pile Up"

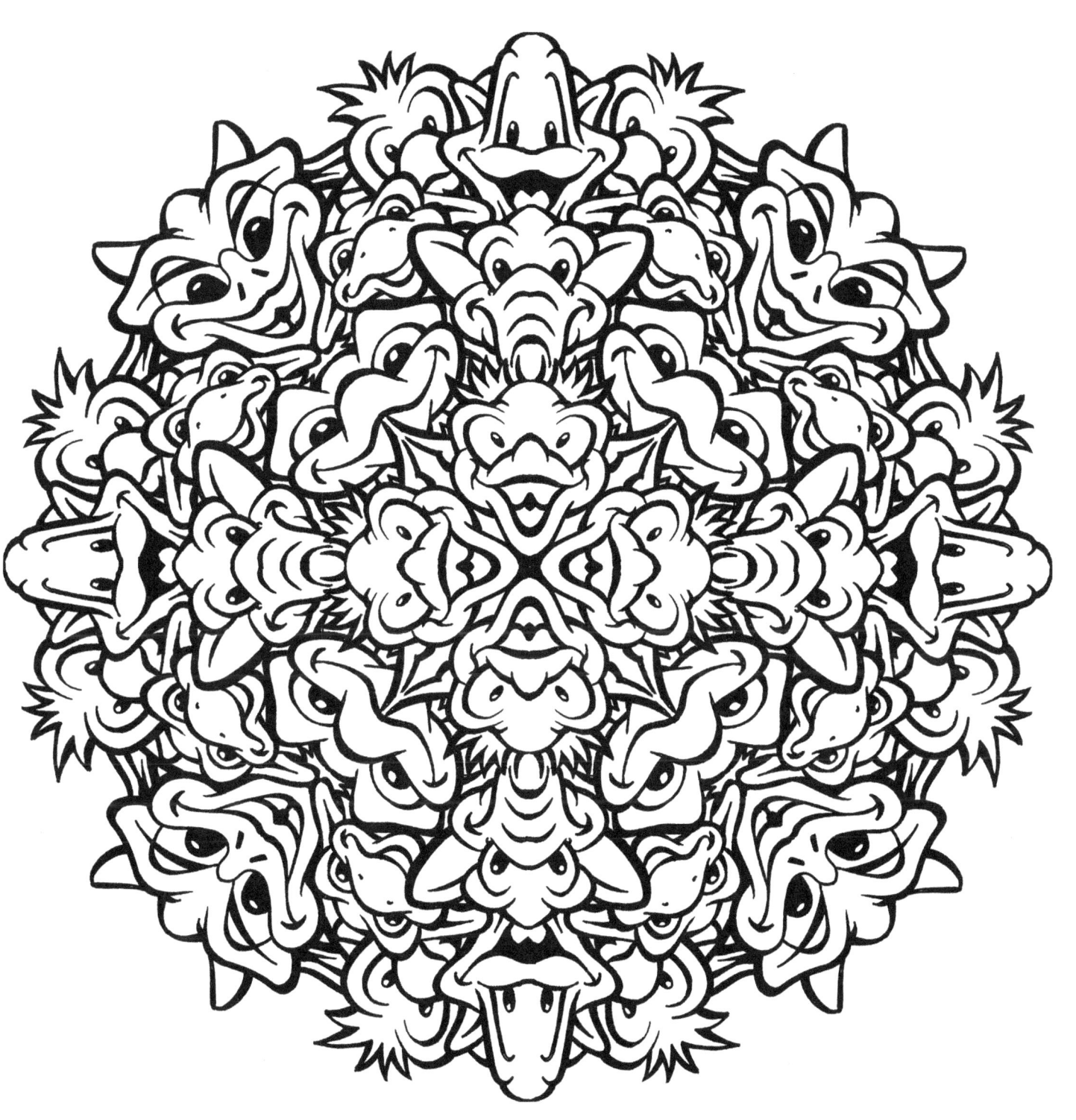

Kaleidoscopic Creatures Book 2
"Creature Fest"

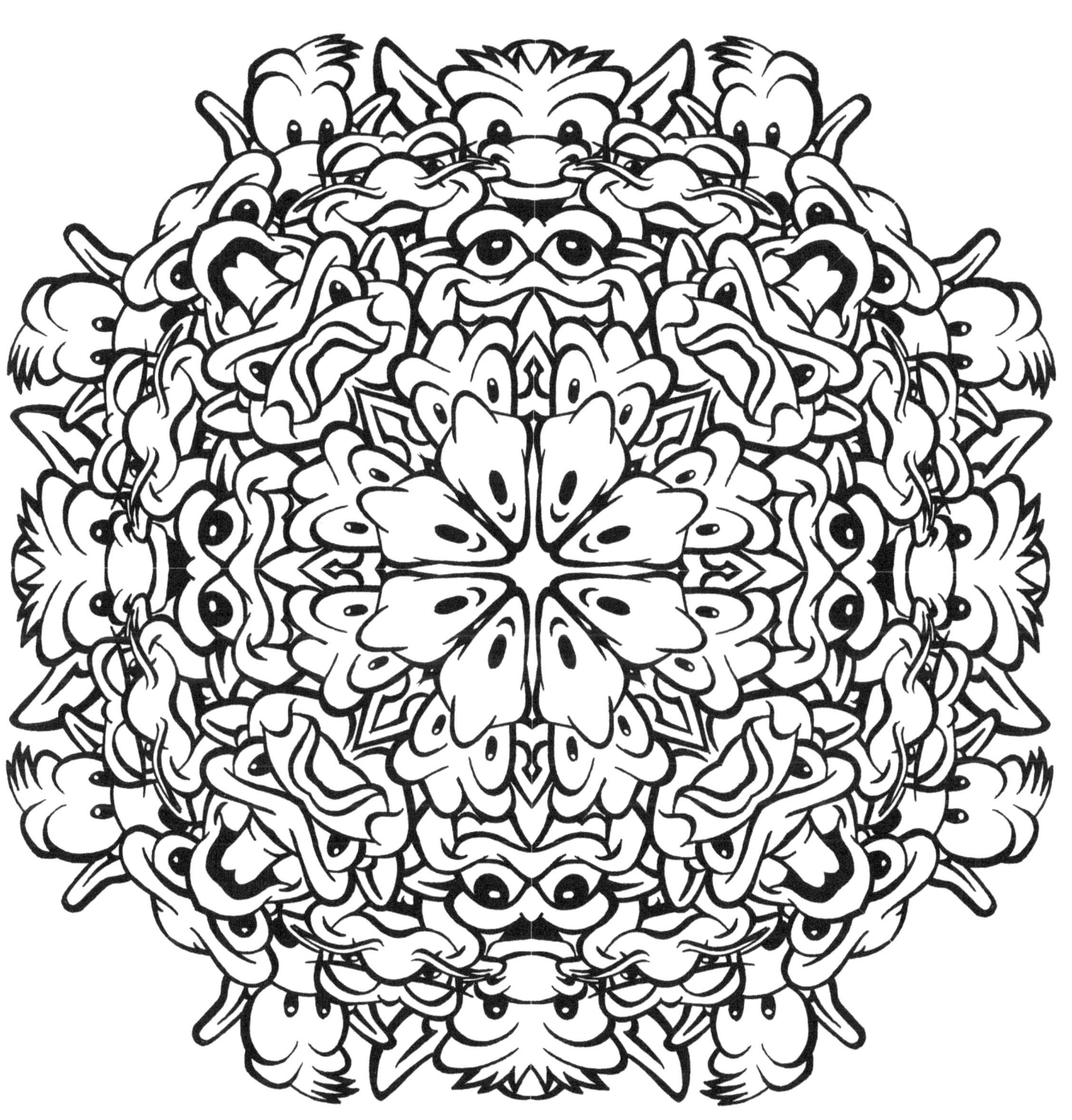

Kaleidoscopic Creatures Book 2
"Creature Clatch"

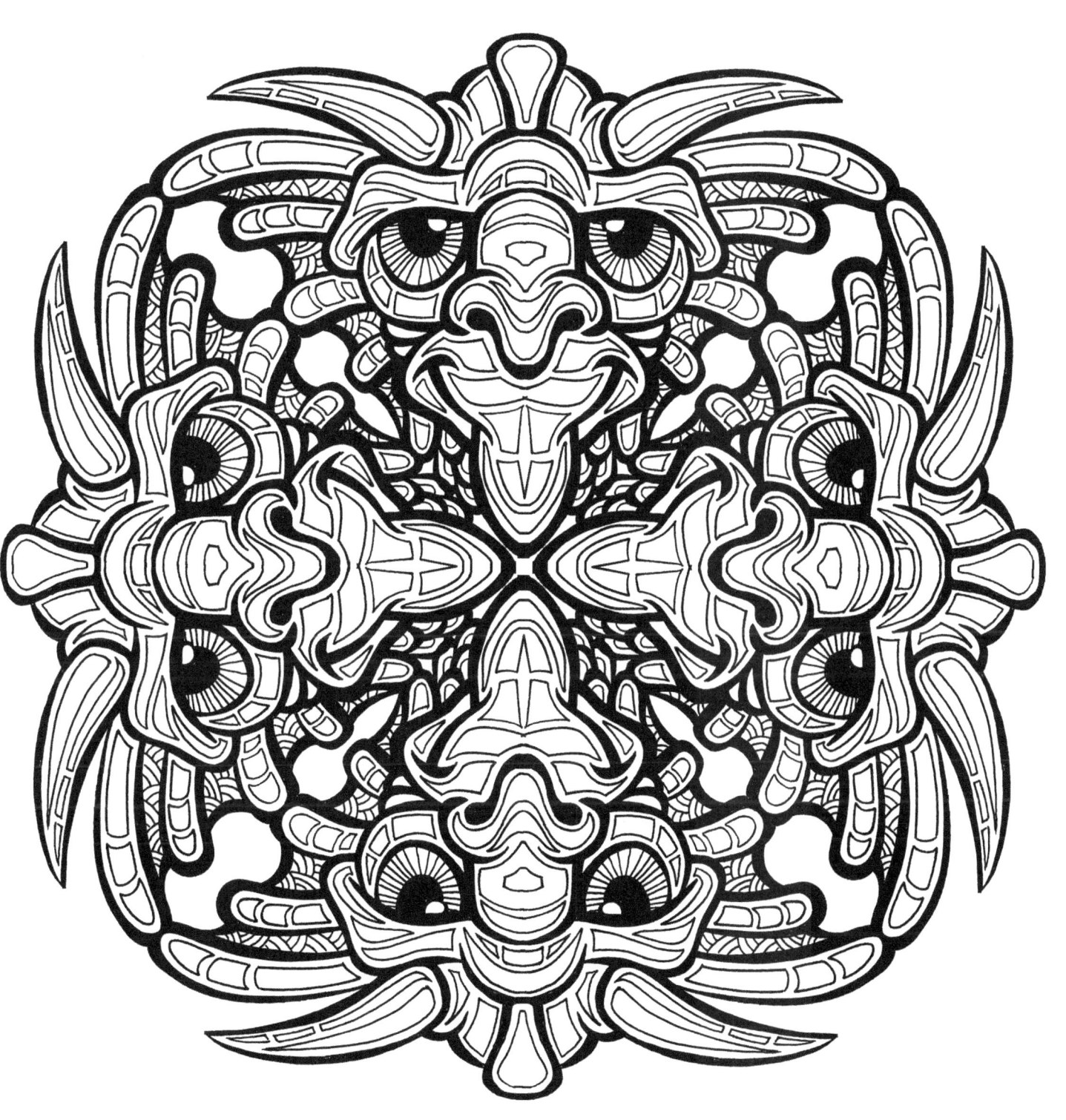

Kaleidoscopic Creatures Book 2
"Dragon Circle"

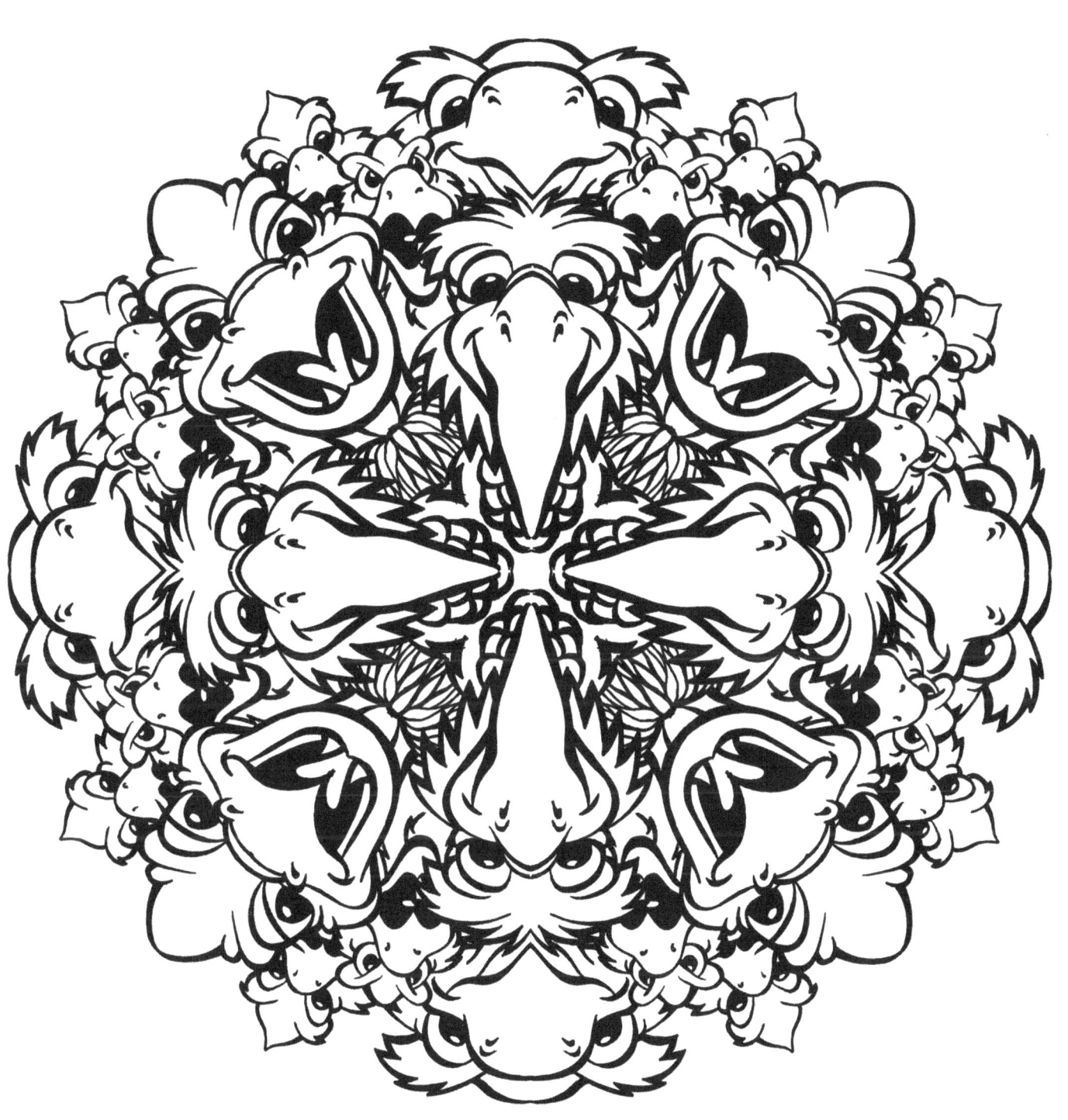

Kaleidoscopic Creatures Book 2
"Birds of a Feather"

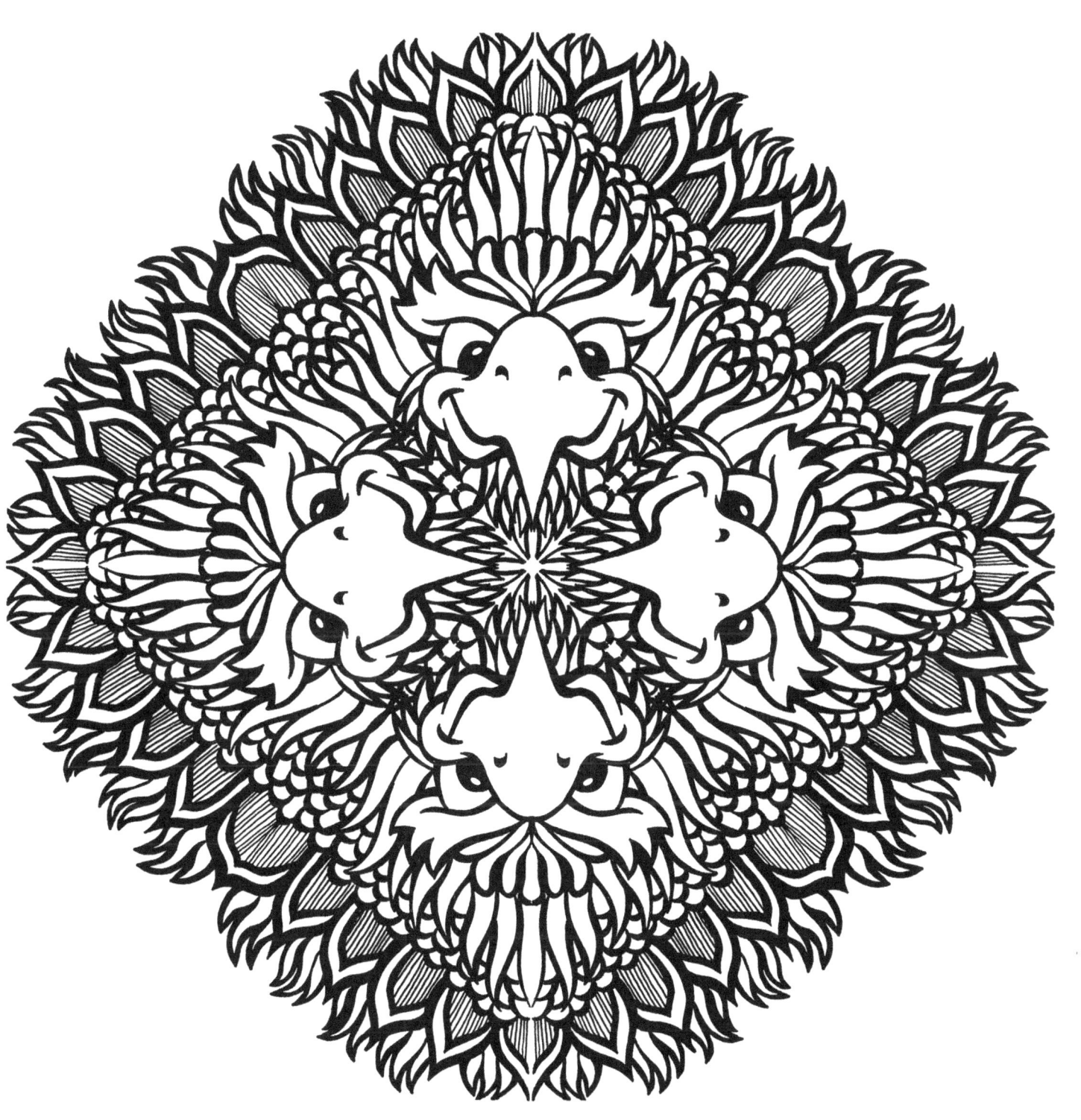

Kaleidoscopic Creatures Book 2
"Shake Your Tail Feathers"

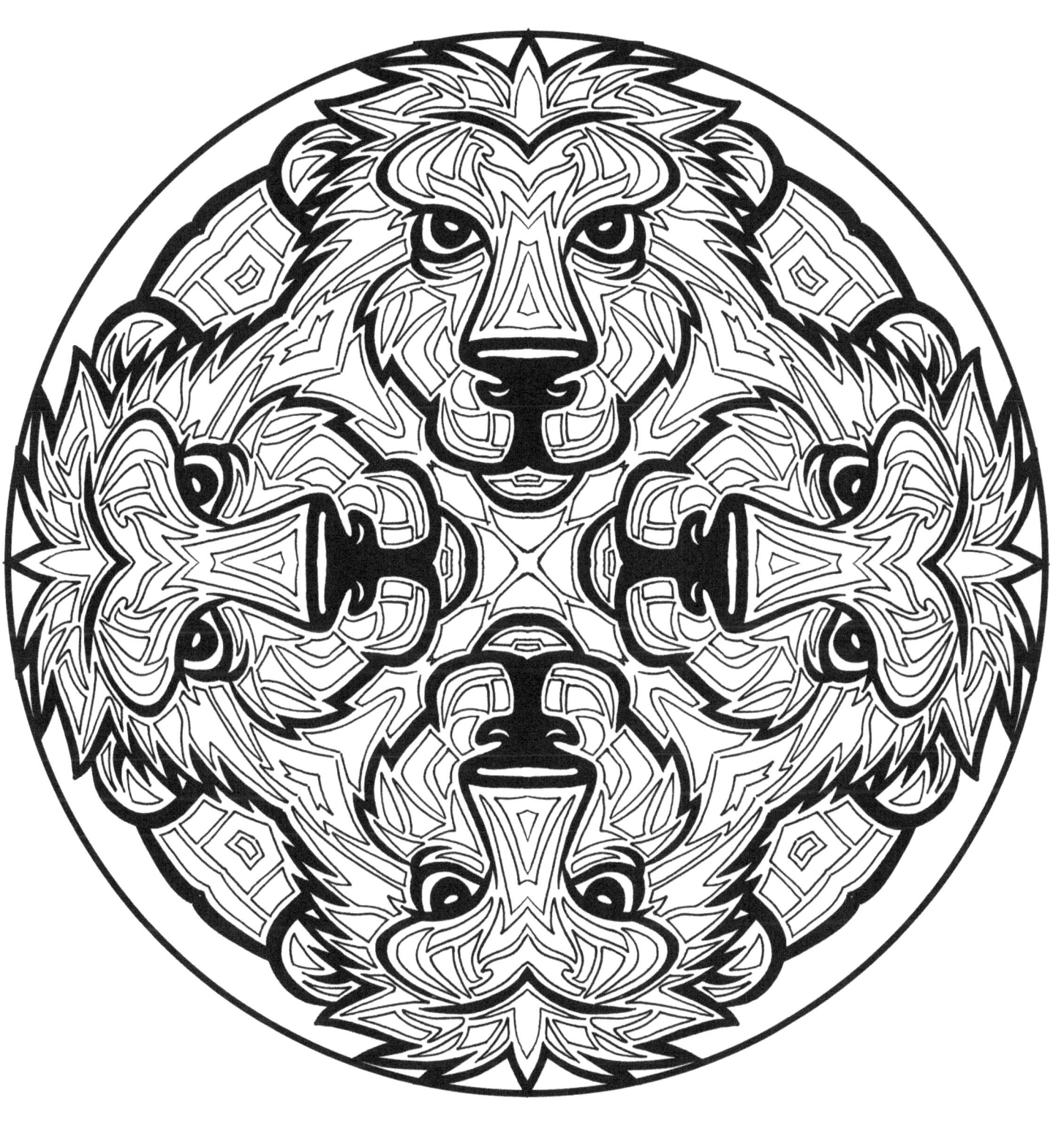

Dave Weiss
Kaleidoscopic Creatures Book 2
"Papa Leone"

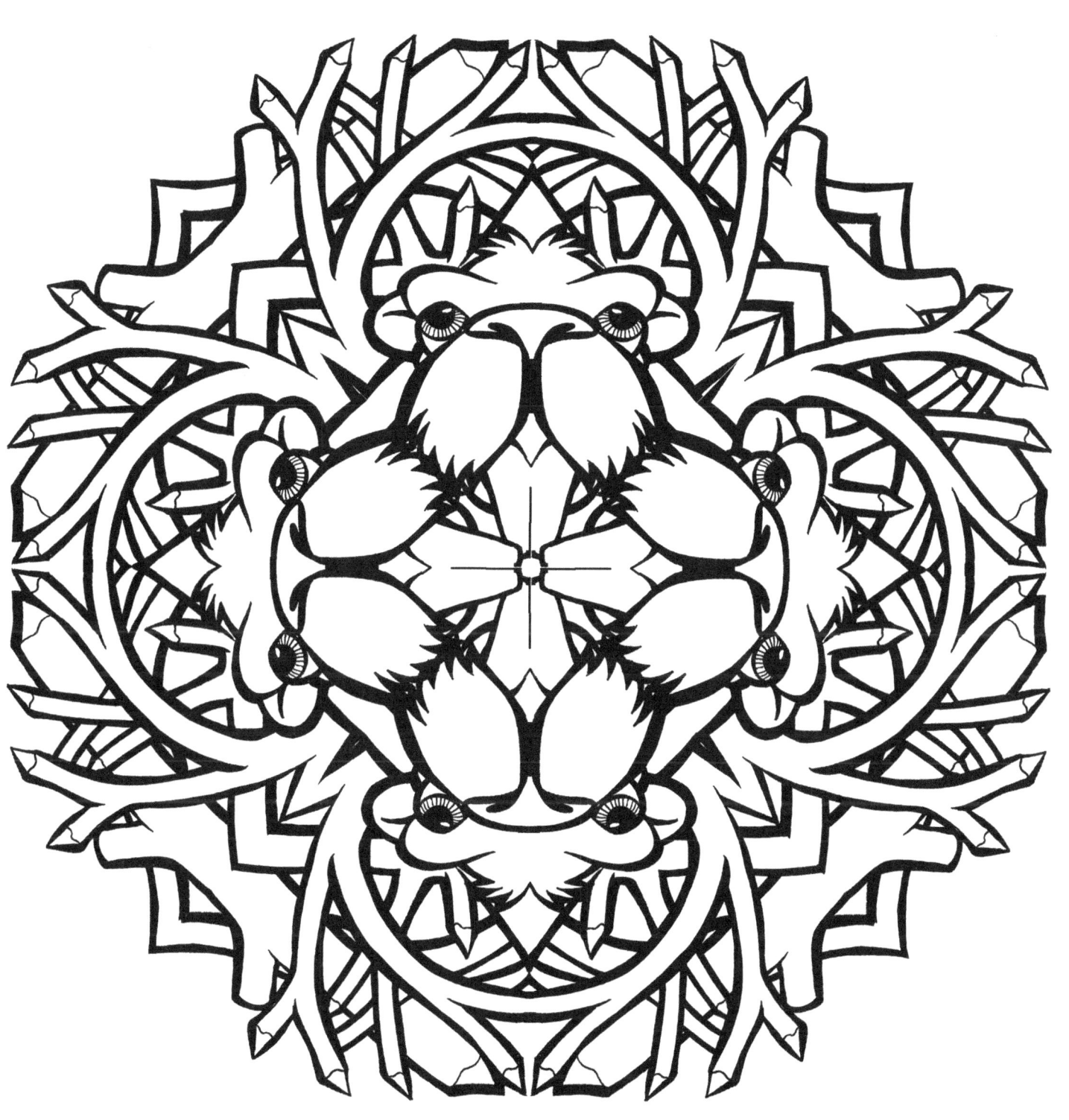

Kaleidoscopic Creatures Book 2
"Dam Beavers"

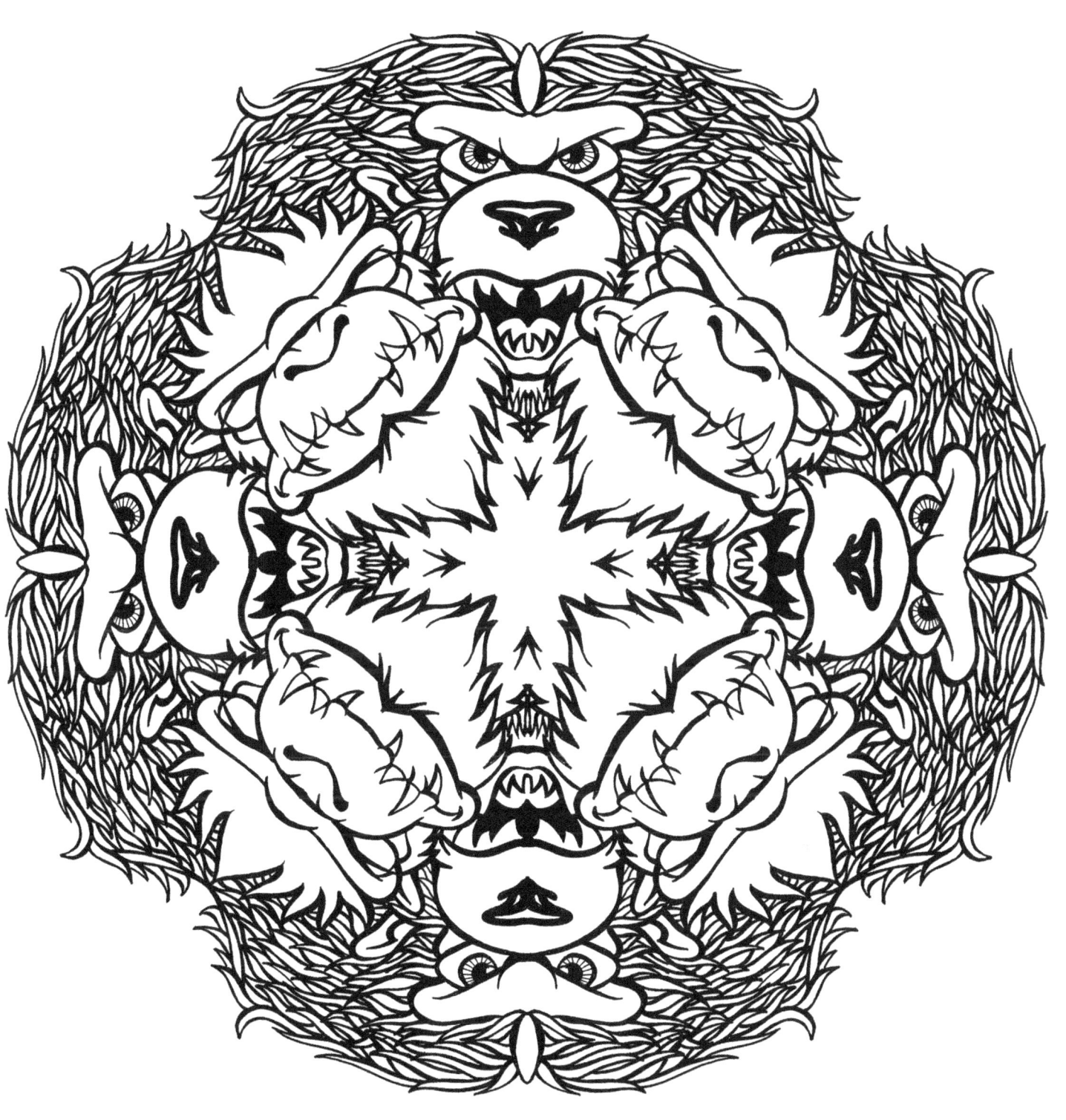

Kaleidoscopic Creatures Book 2
"Squatch and Yeti"

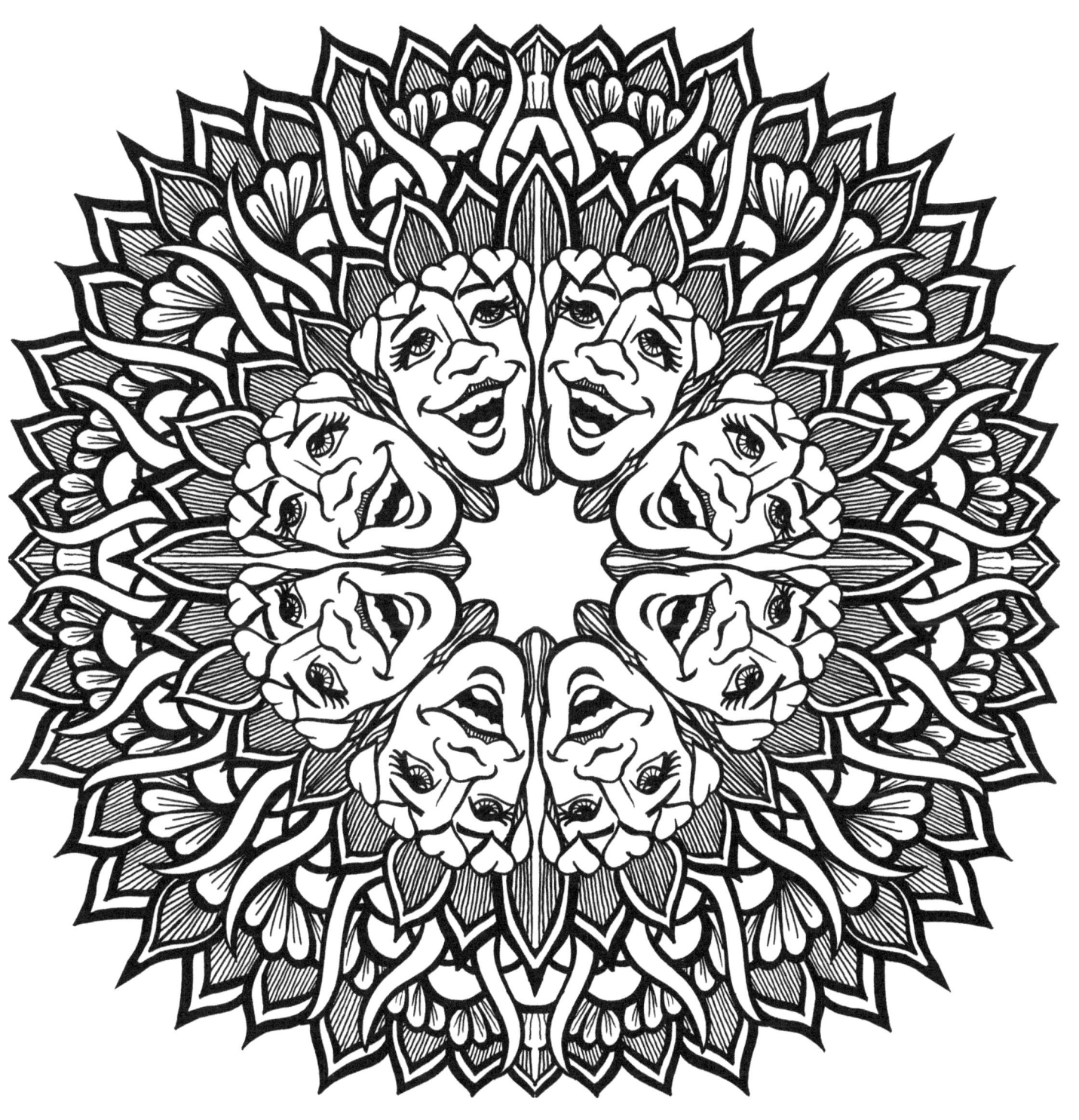

Kaleidoscopic Creatures Book 2
"Garden Fairy"

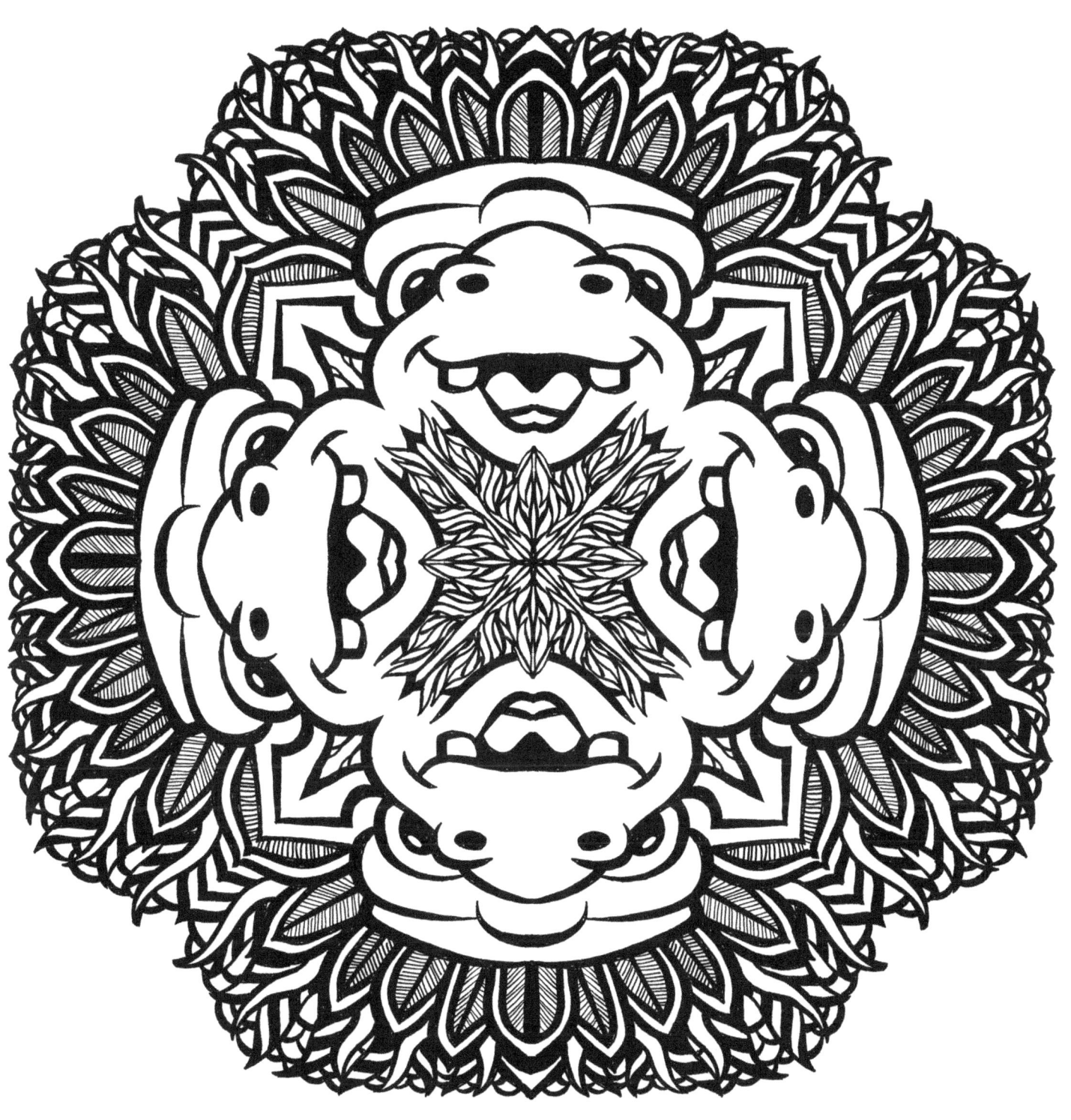

Kaleidoscopic Creatures Book 2
"Mayan Hippo"

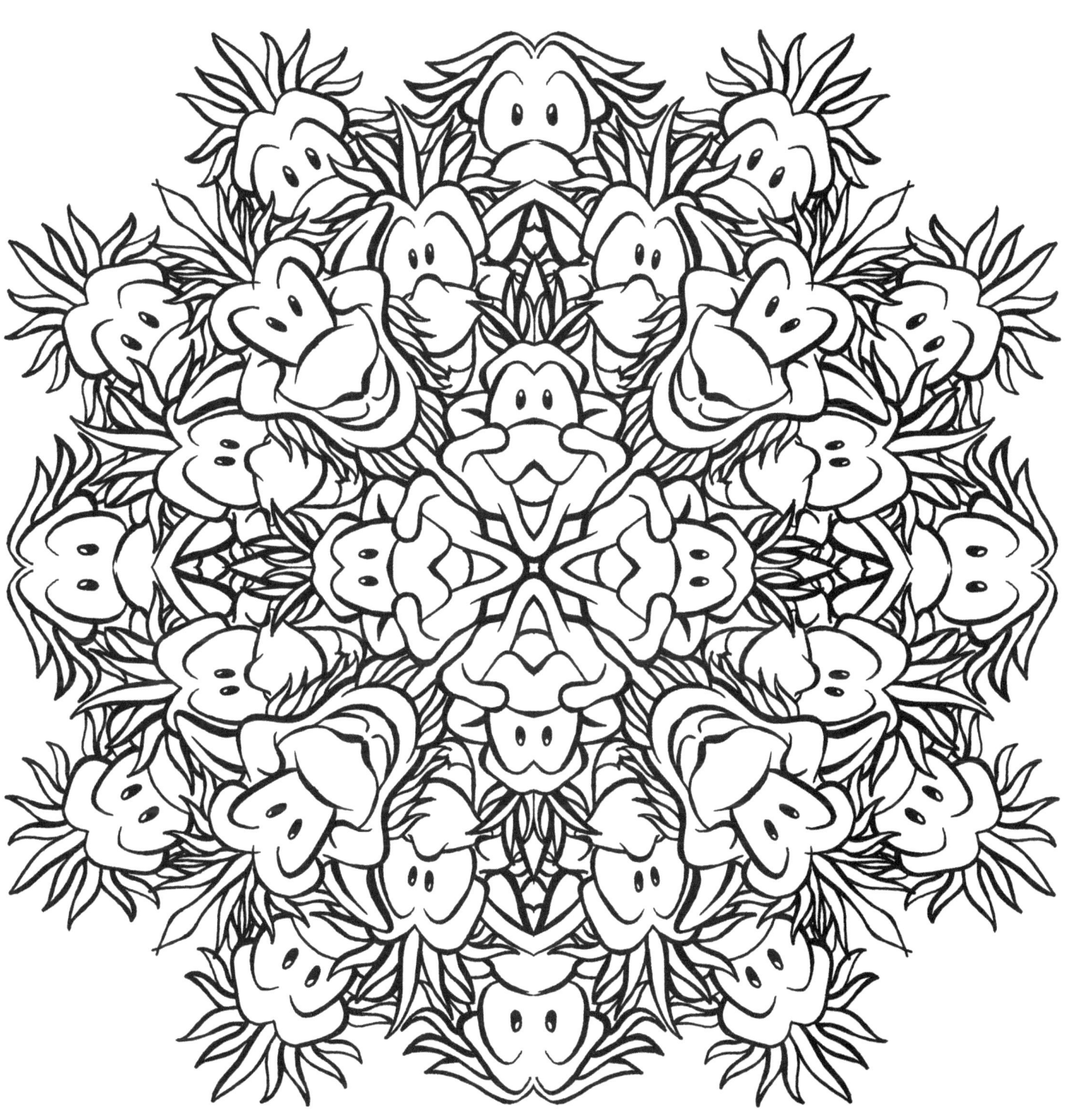

Kaleidoscopic Creatures Book 2
"Wild Hairies"

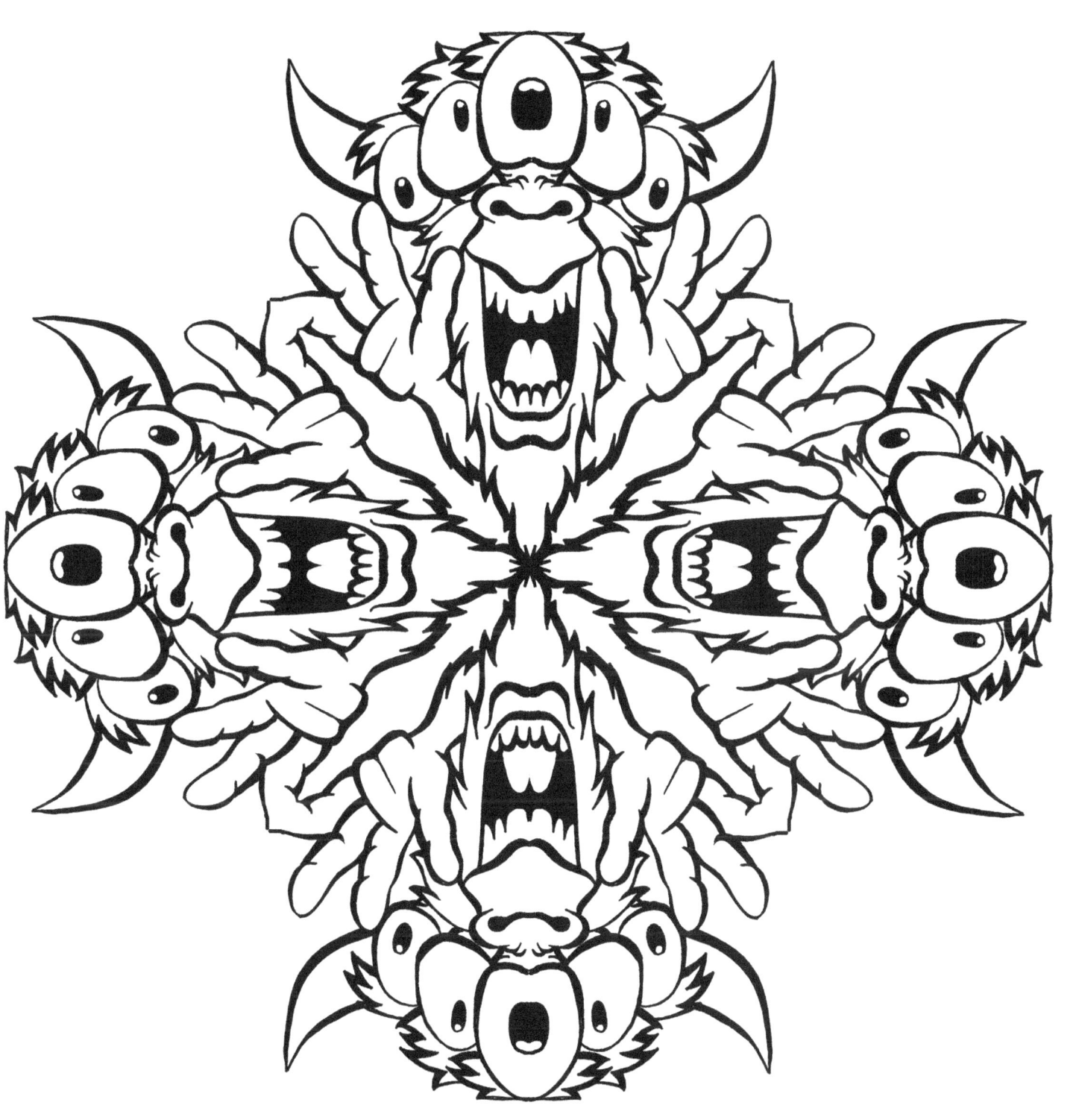

Kaleidoscopic Creatures Book 2
"WooHoo"

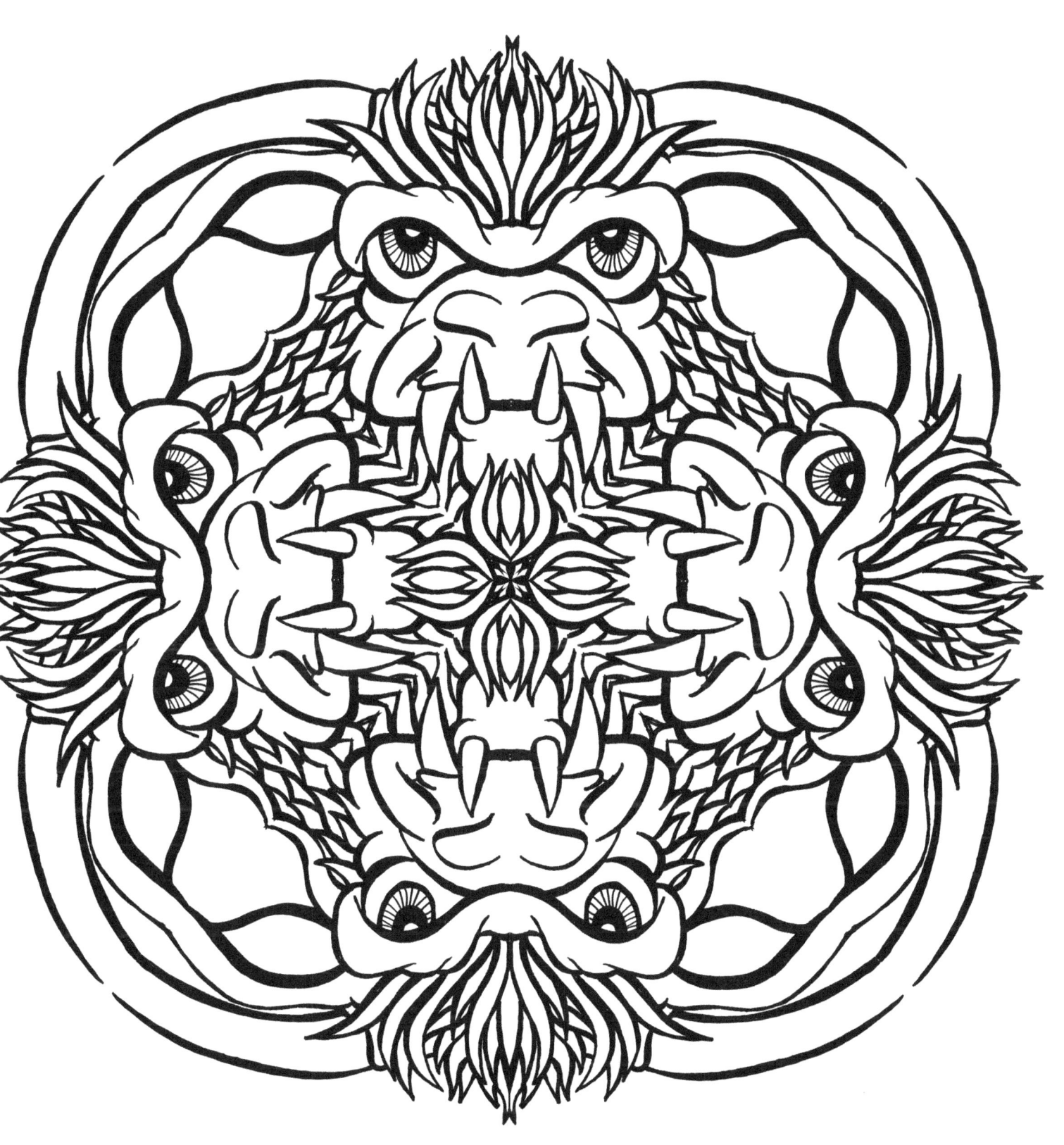

Kaleidoscopic Creatures Book 2
"Fanged Goat"

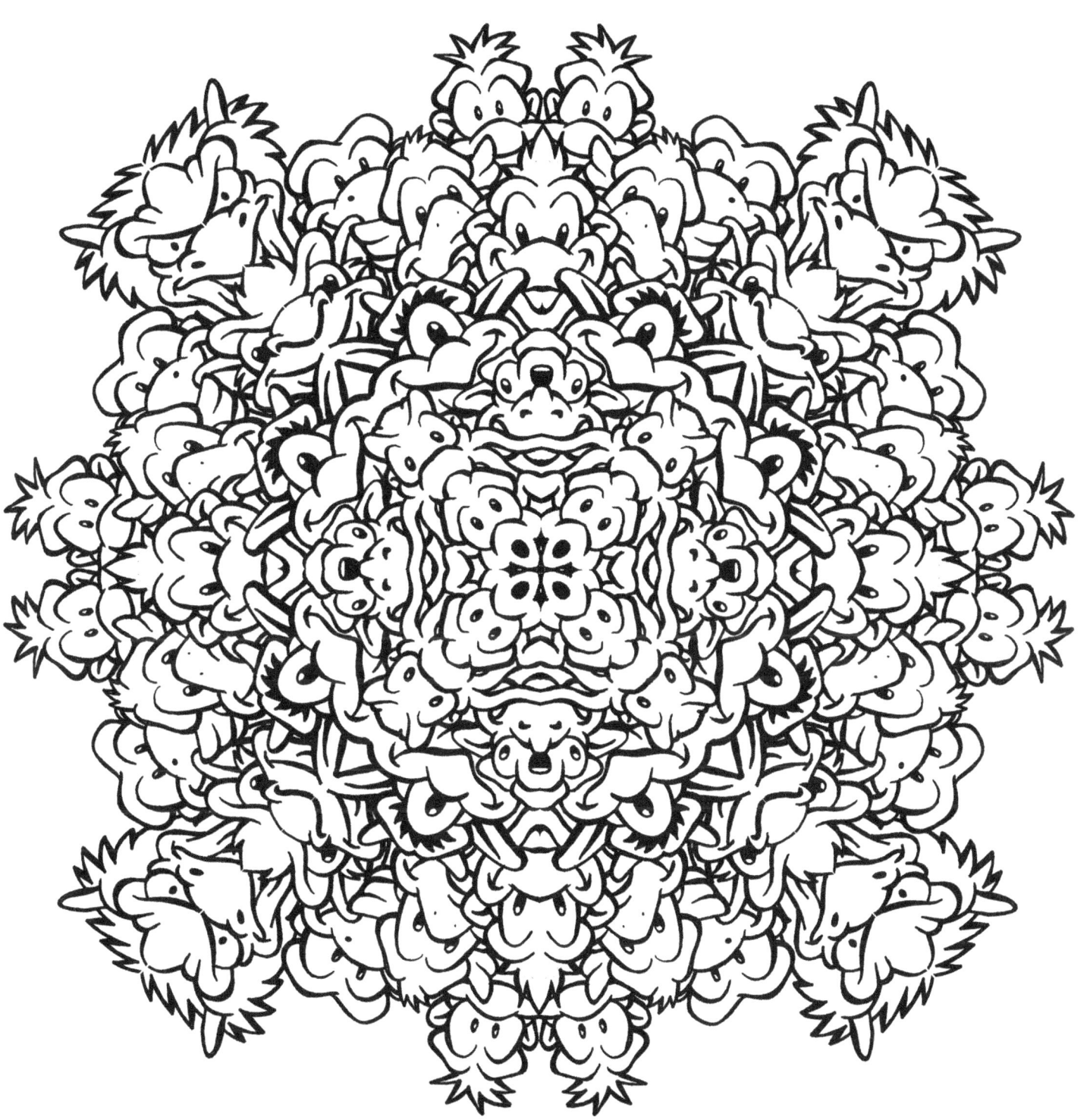

Kaleidoscopic Creatures Book 2
"Creathering"

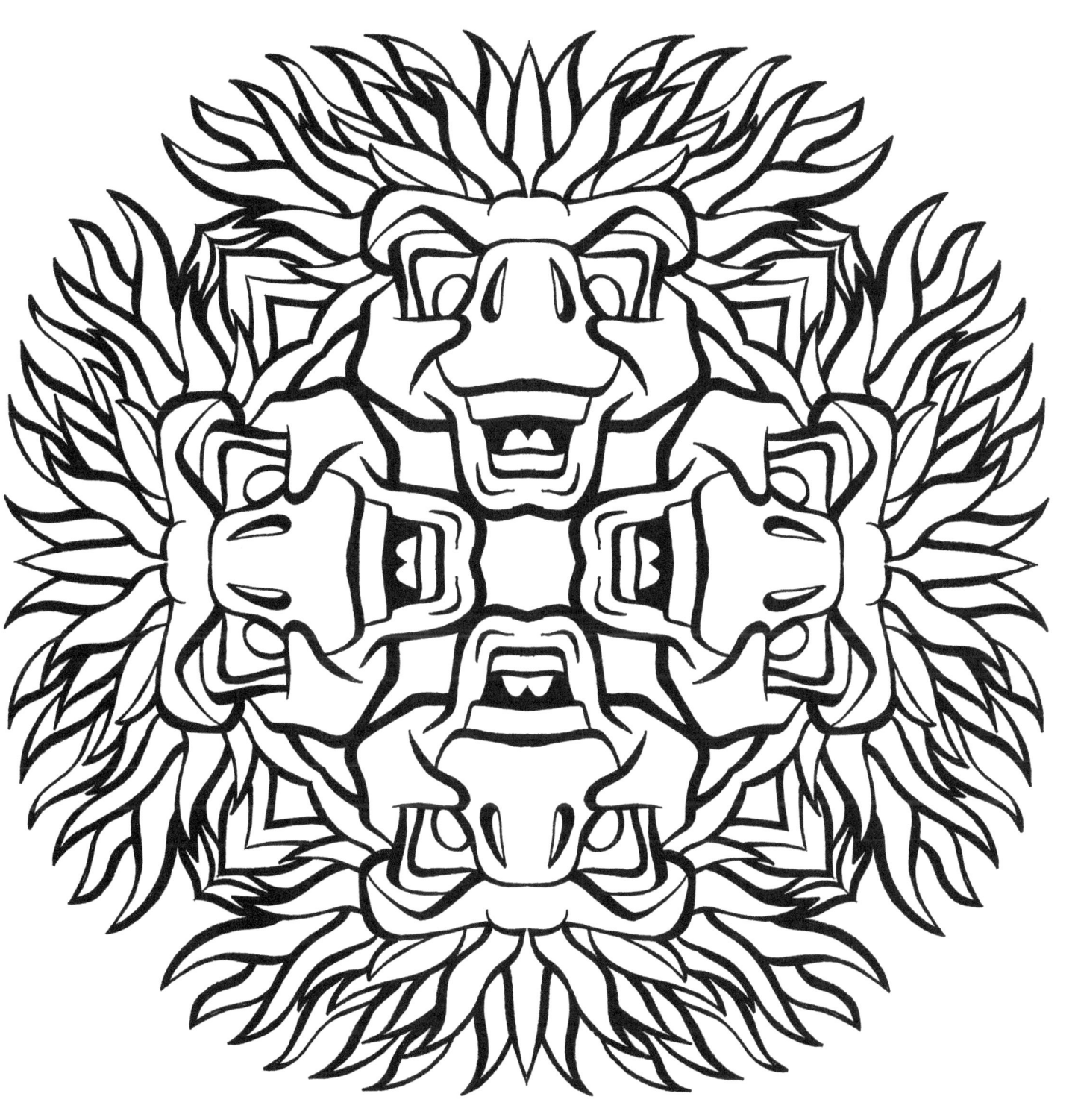

Kaleidoscopic Creatures Book 2
"Fire Turtle"

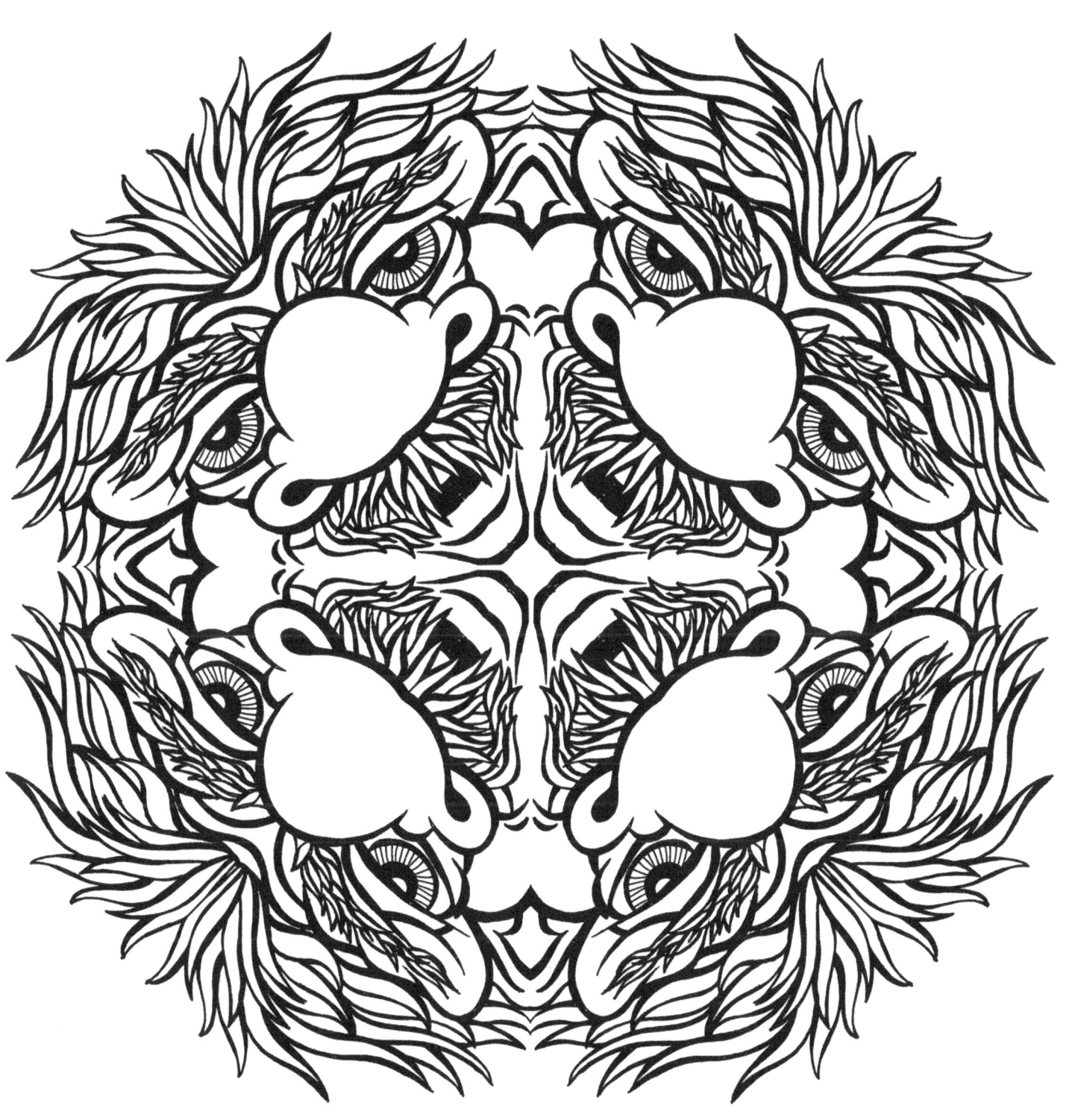

Kaleidoscopic Creatures Book 2
"A-Gnome-aly"

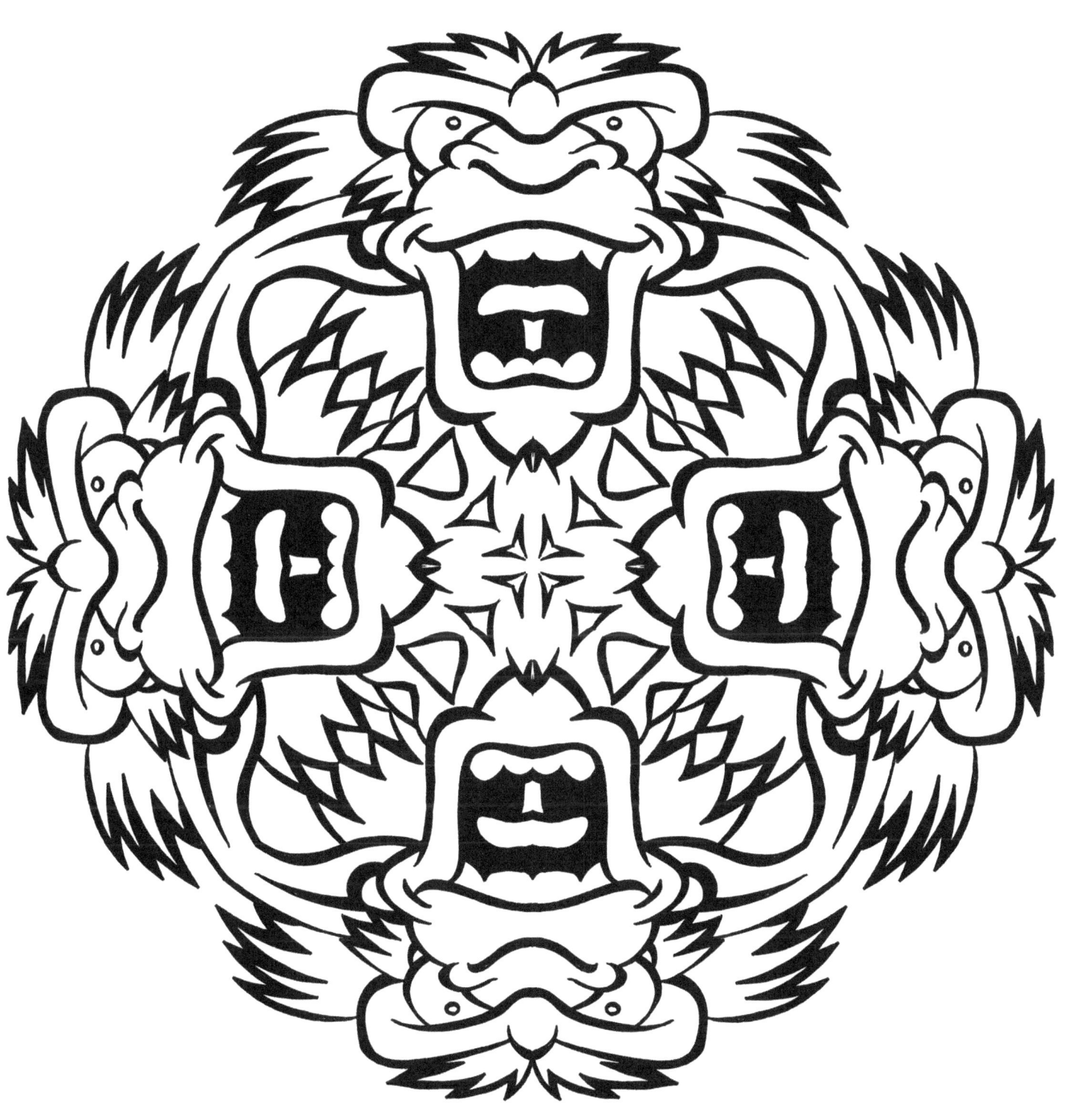

Kaleidoscopic Creatures Book 2
"Beastlies"

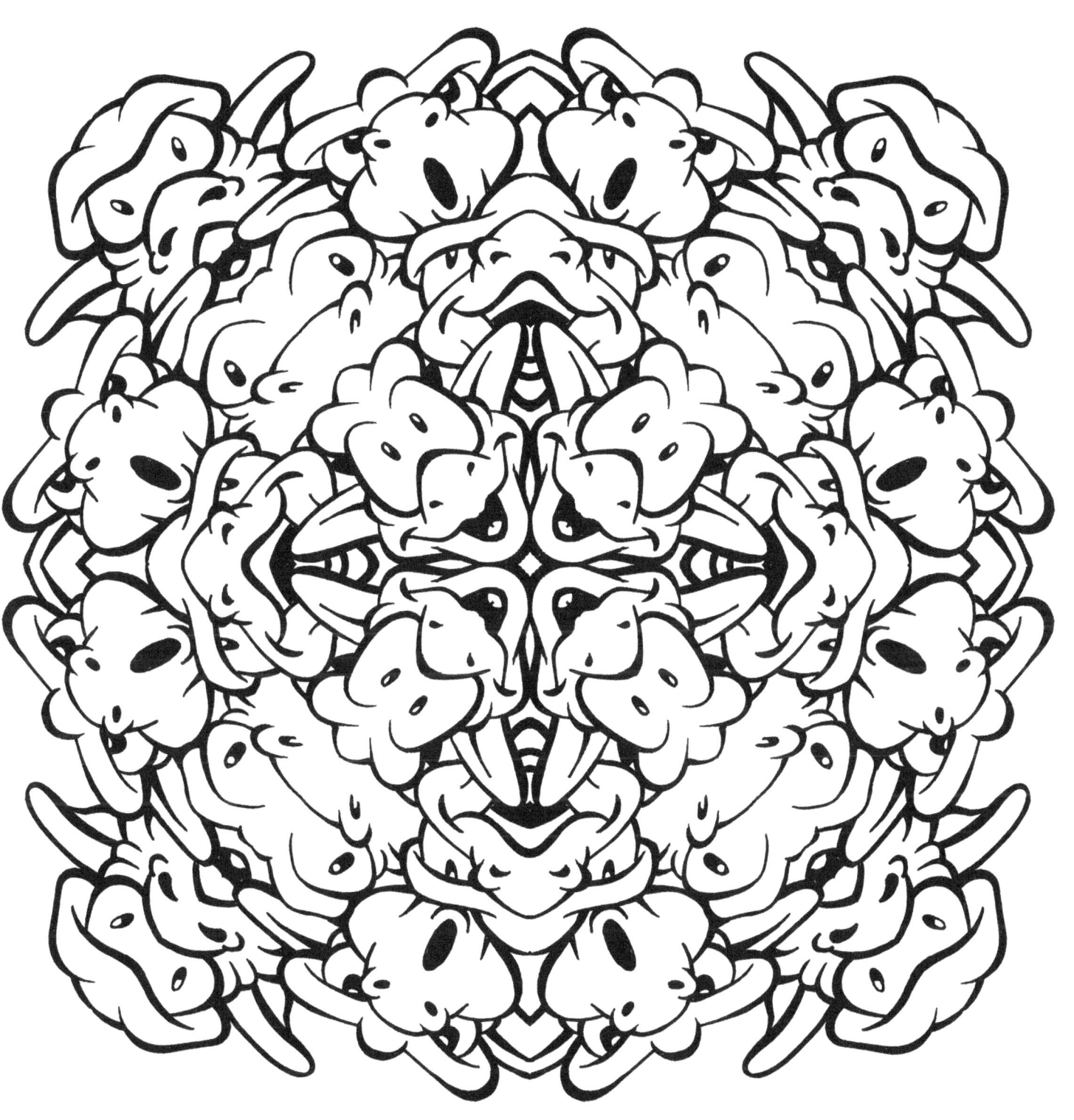

Kaleidoscopic Creatures Book 2
"Creature Confusion"

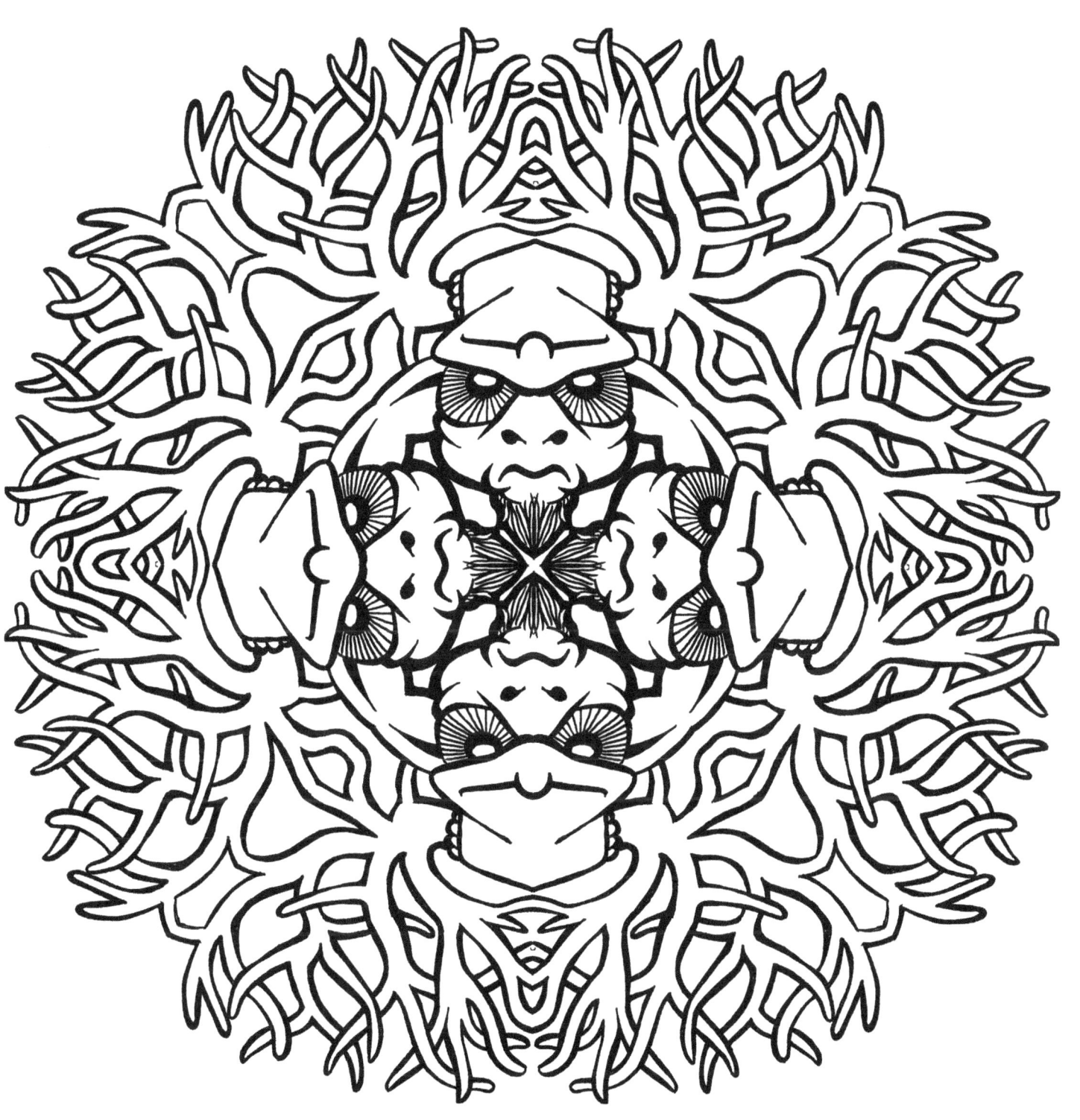

Kaleidoscopic Creatures Book 2
"Antlerior Motive"

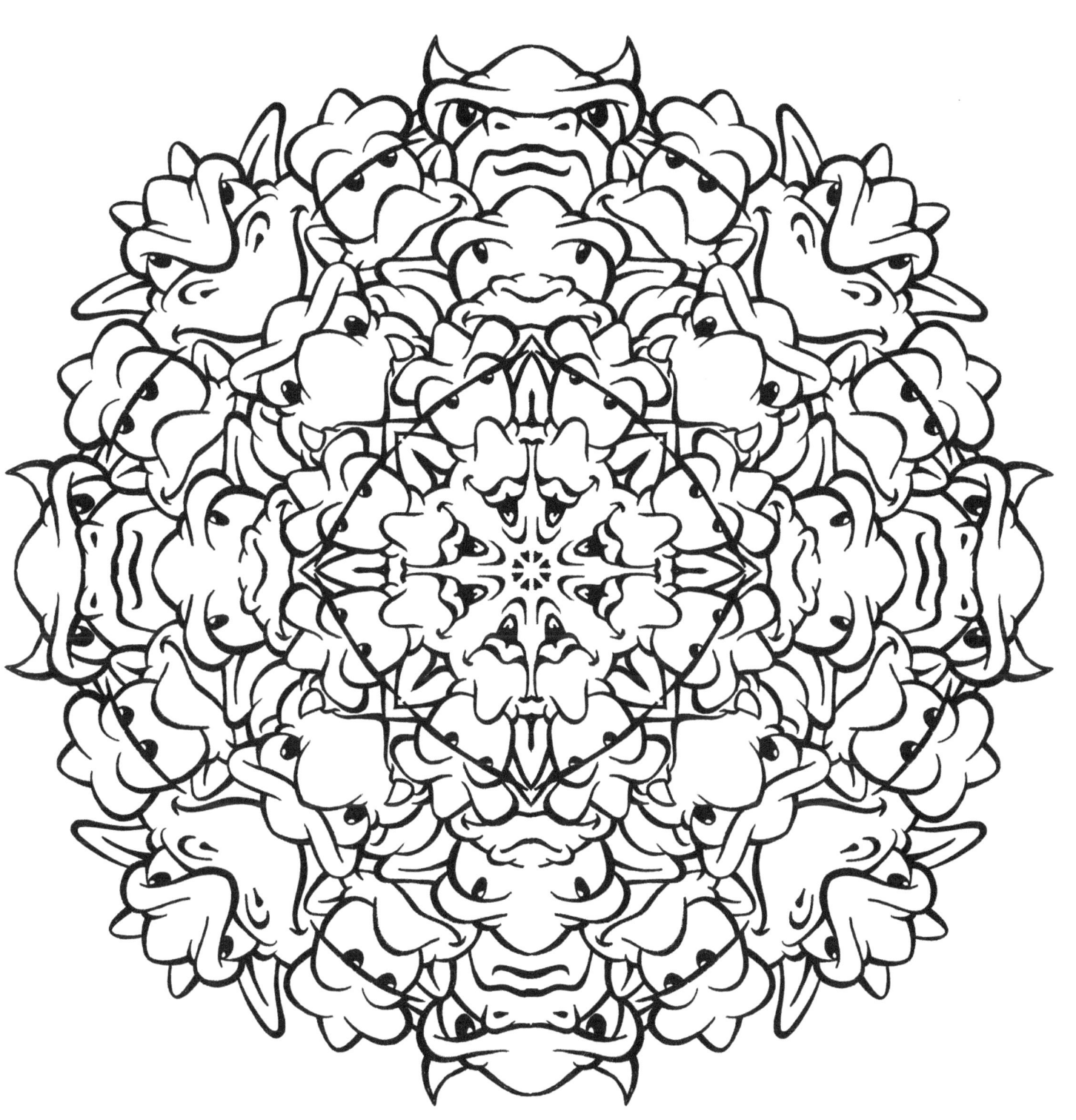

Kaleidoscopic Creatures Book 2
"Creature Cluster 6"

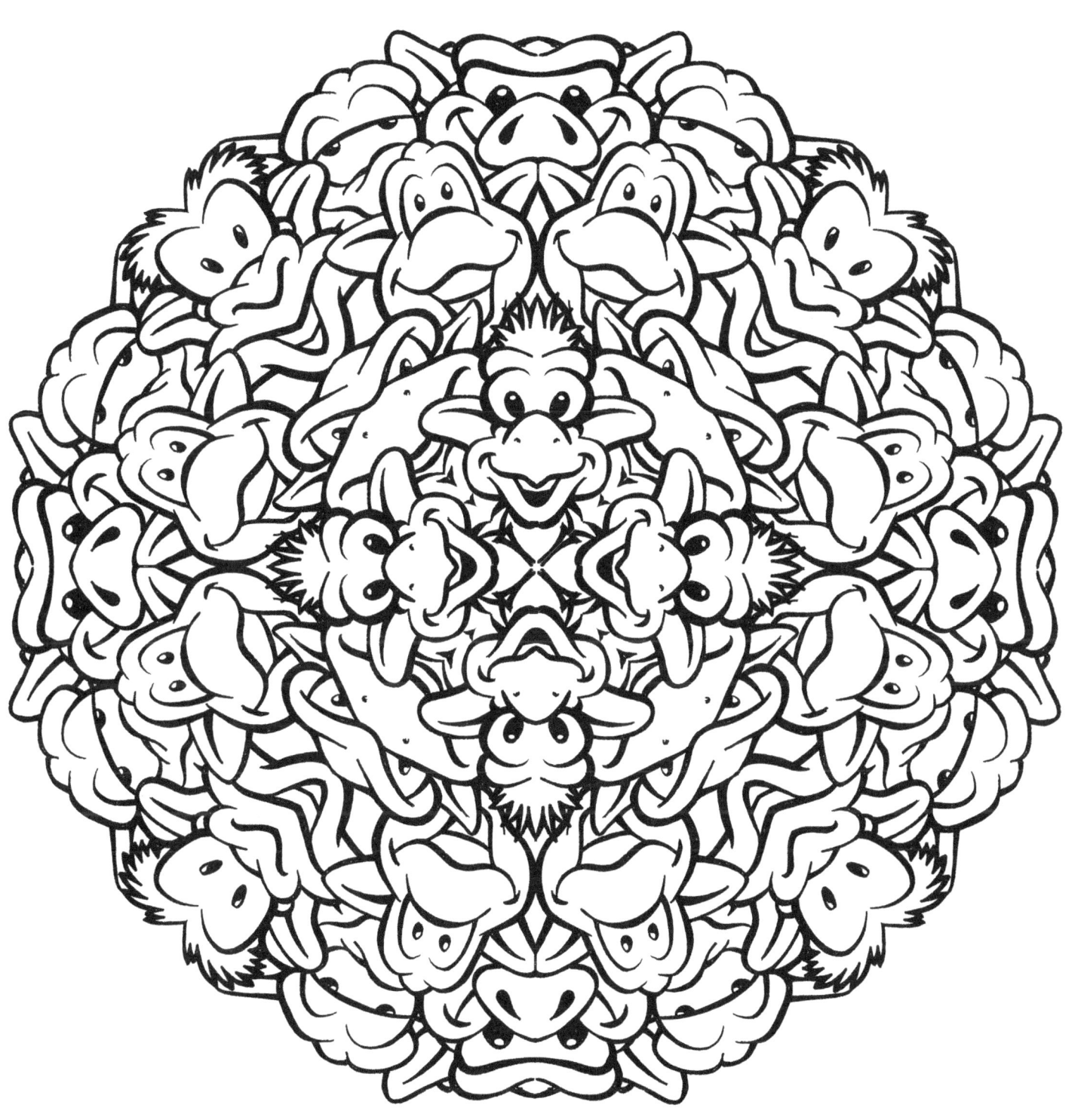

Kaleidoscopic Creatures Book 2
"Creature Crew"

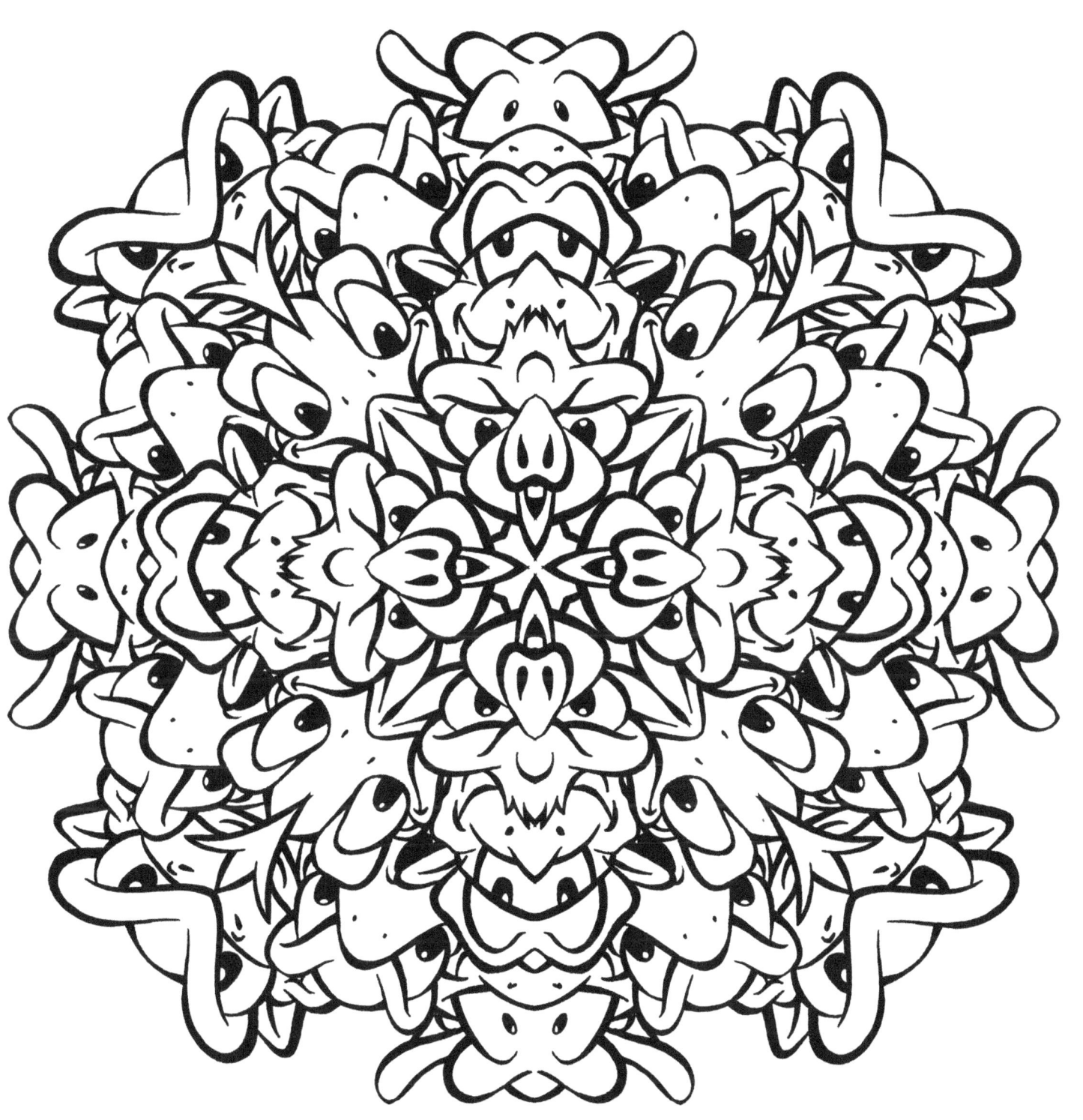

Kaleidoscopic Creatures Book 2
"Creature Cluster 7"

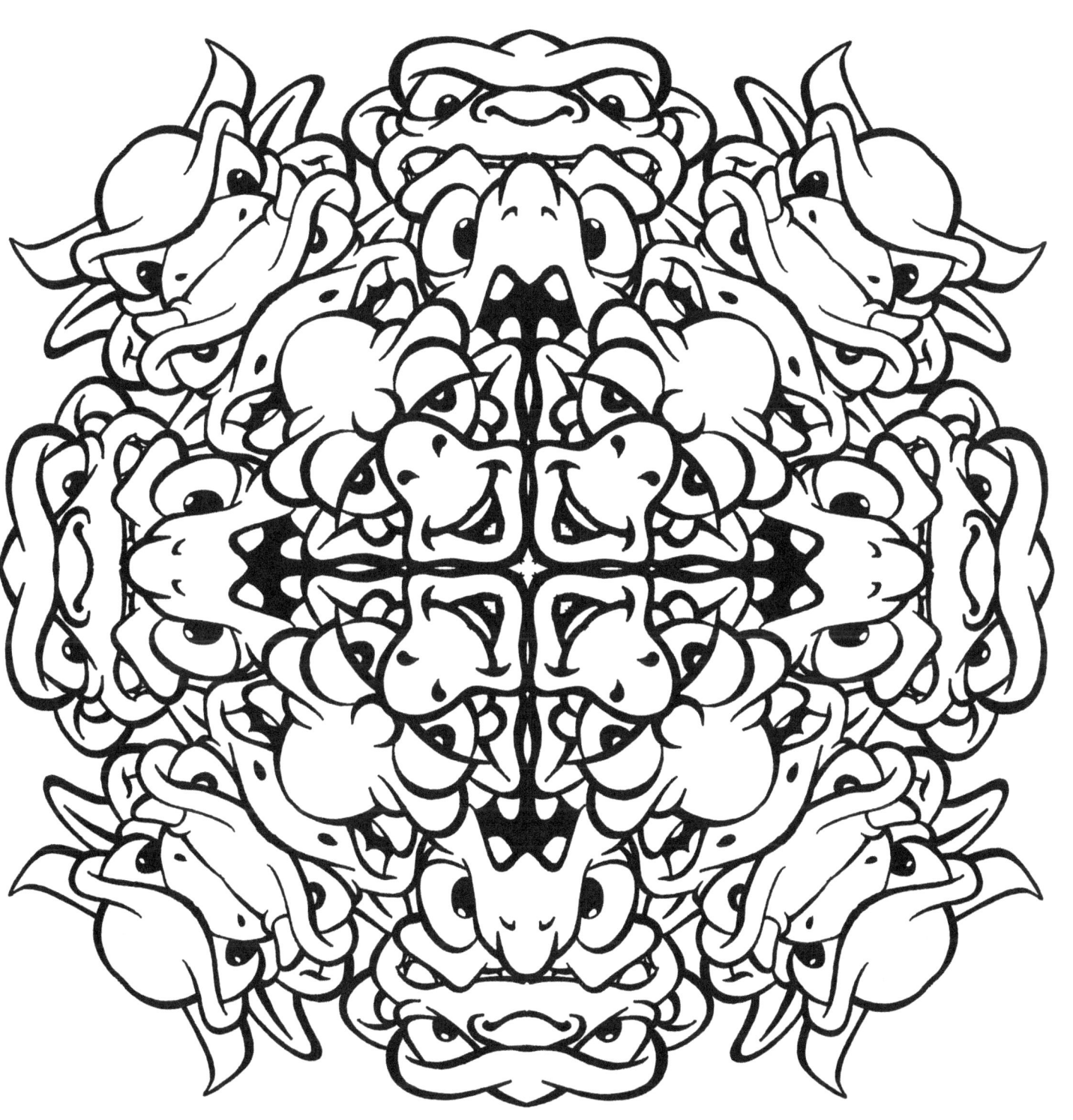

Kaleidoscopic Creatures Book 2
"Creature Cluster 8"

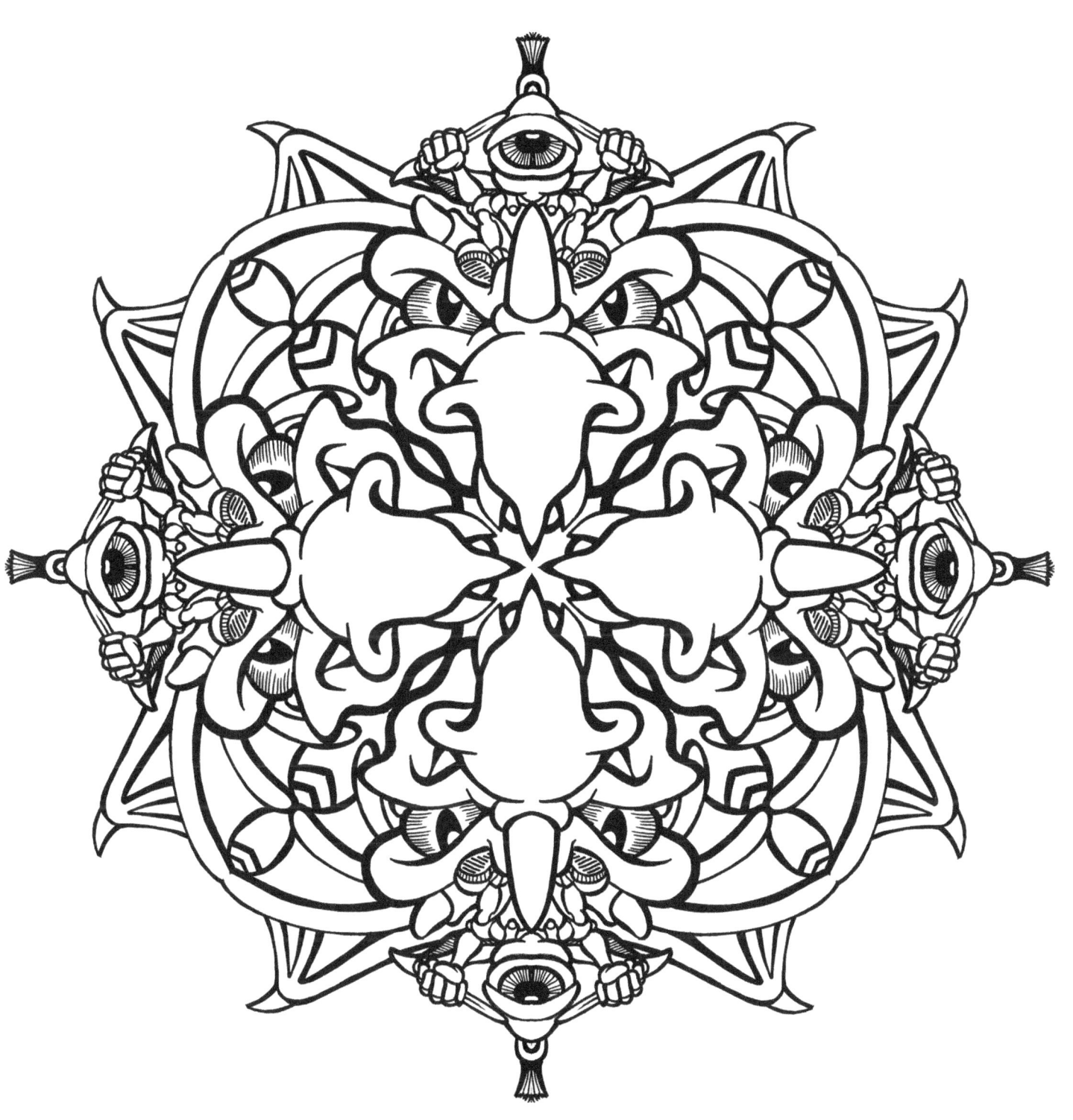

Kaleidoscopic Creatures Book 2
"Dragon Riders"

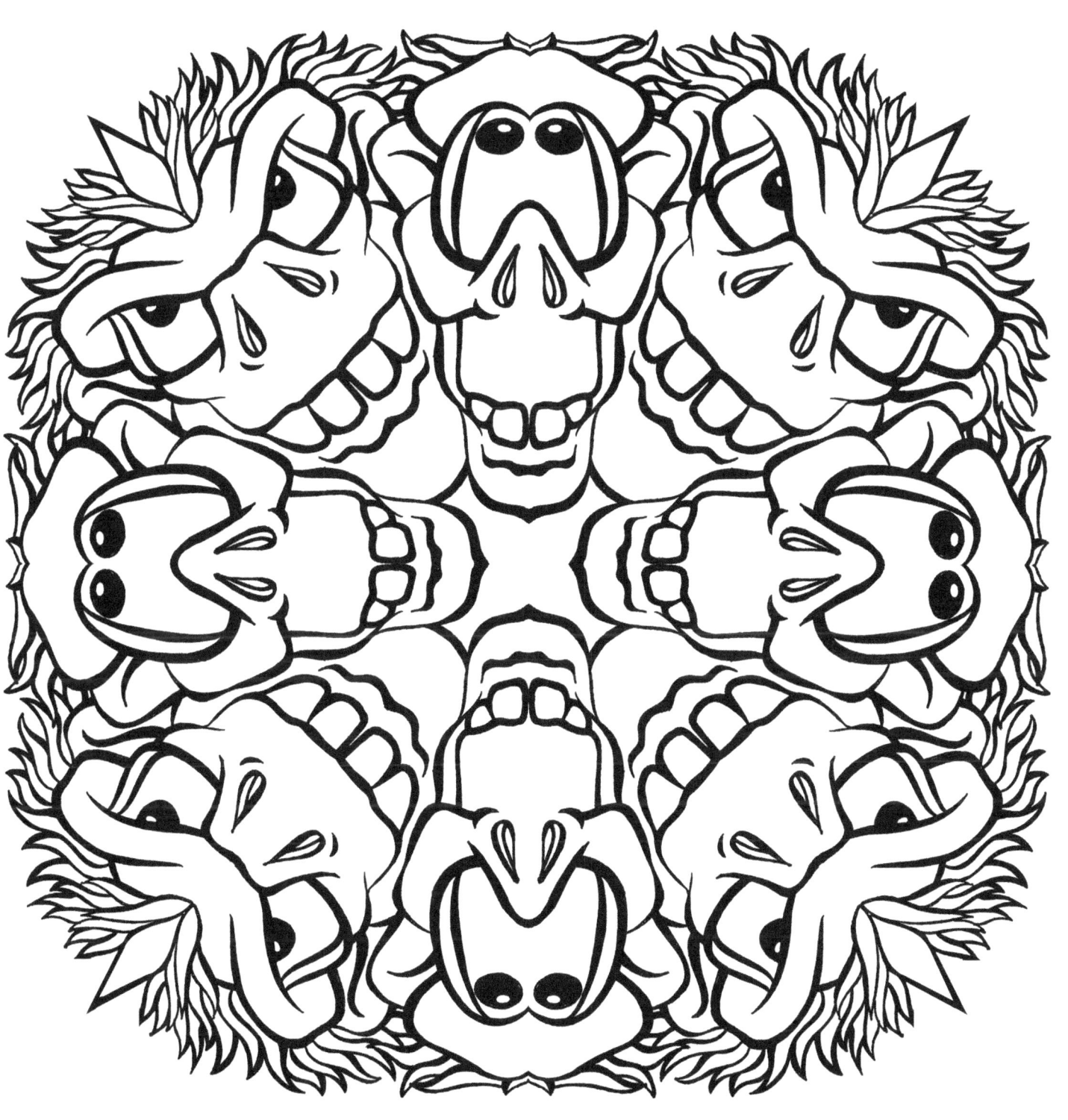

Kaleidoscopic Creatures Book 2
"Bubba and Stan"

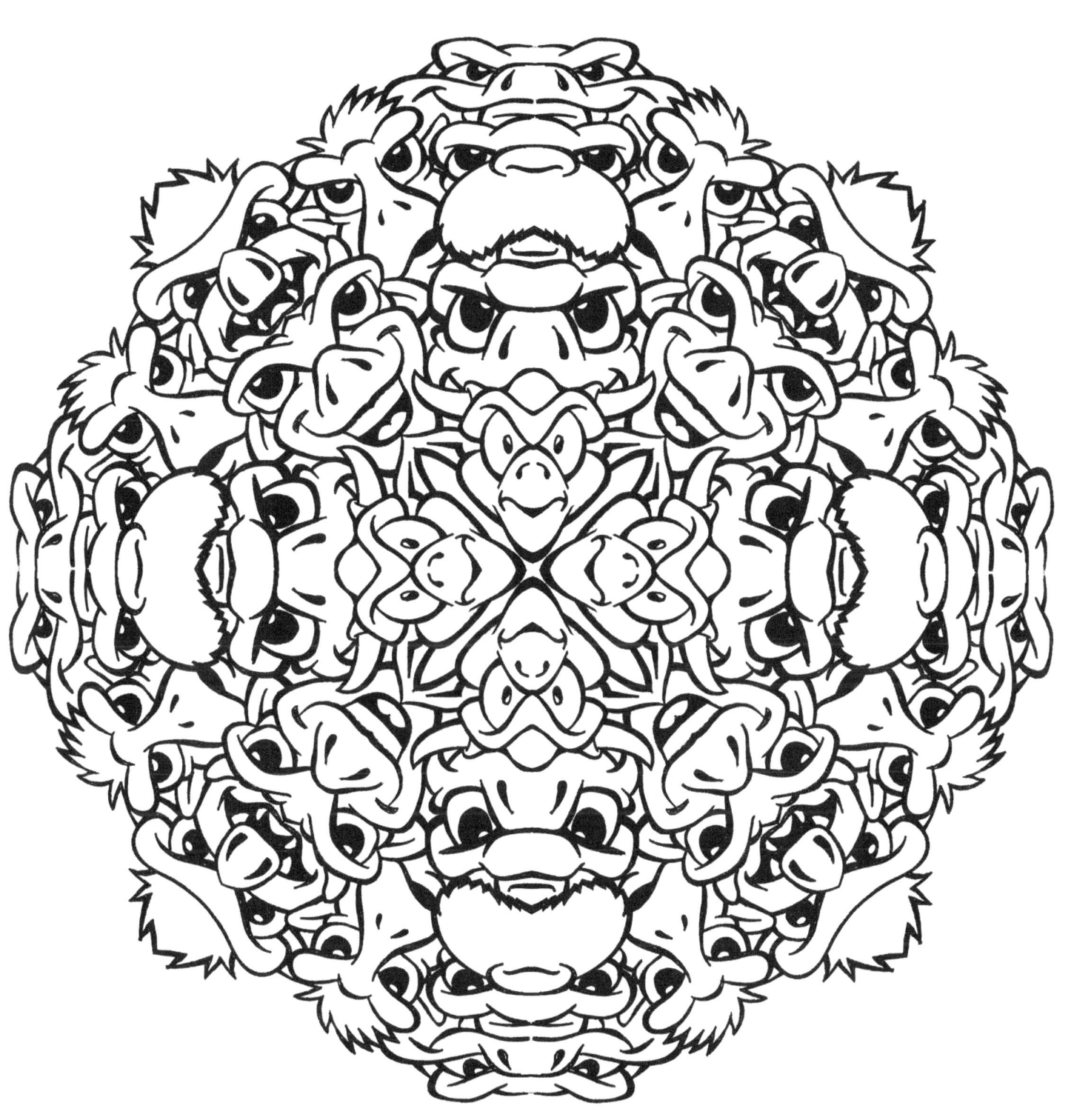

Kaleidoscopic Creatures Book 2
"Bad Apples"

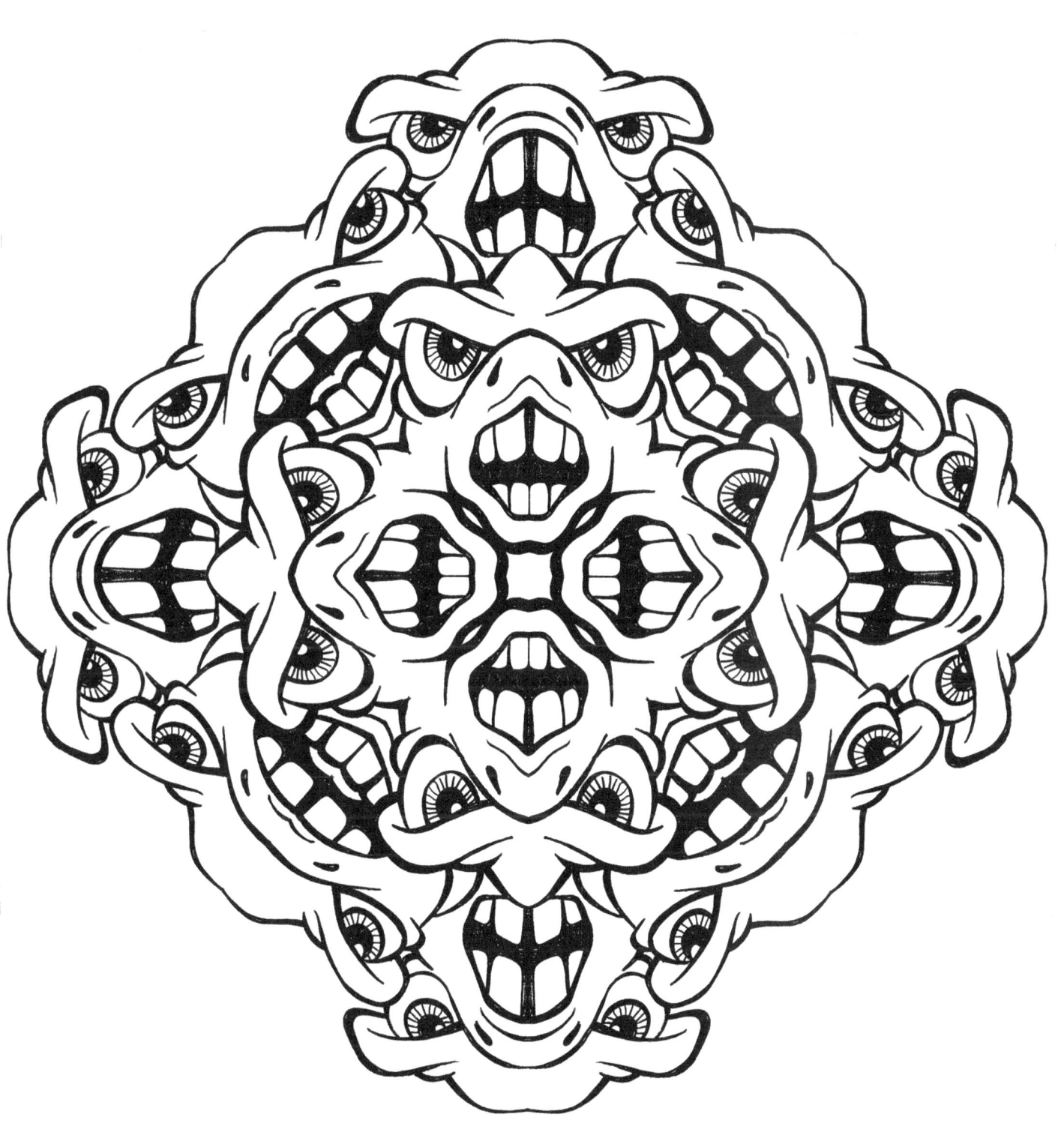

Kaleidoscopic Creatures Book 1
"Growlies"

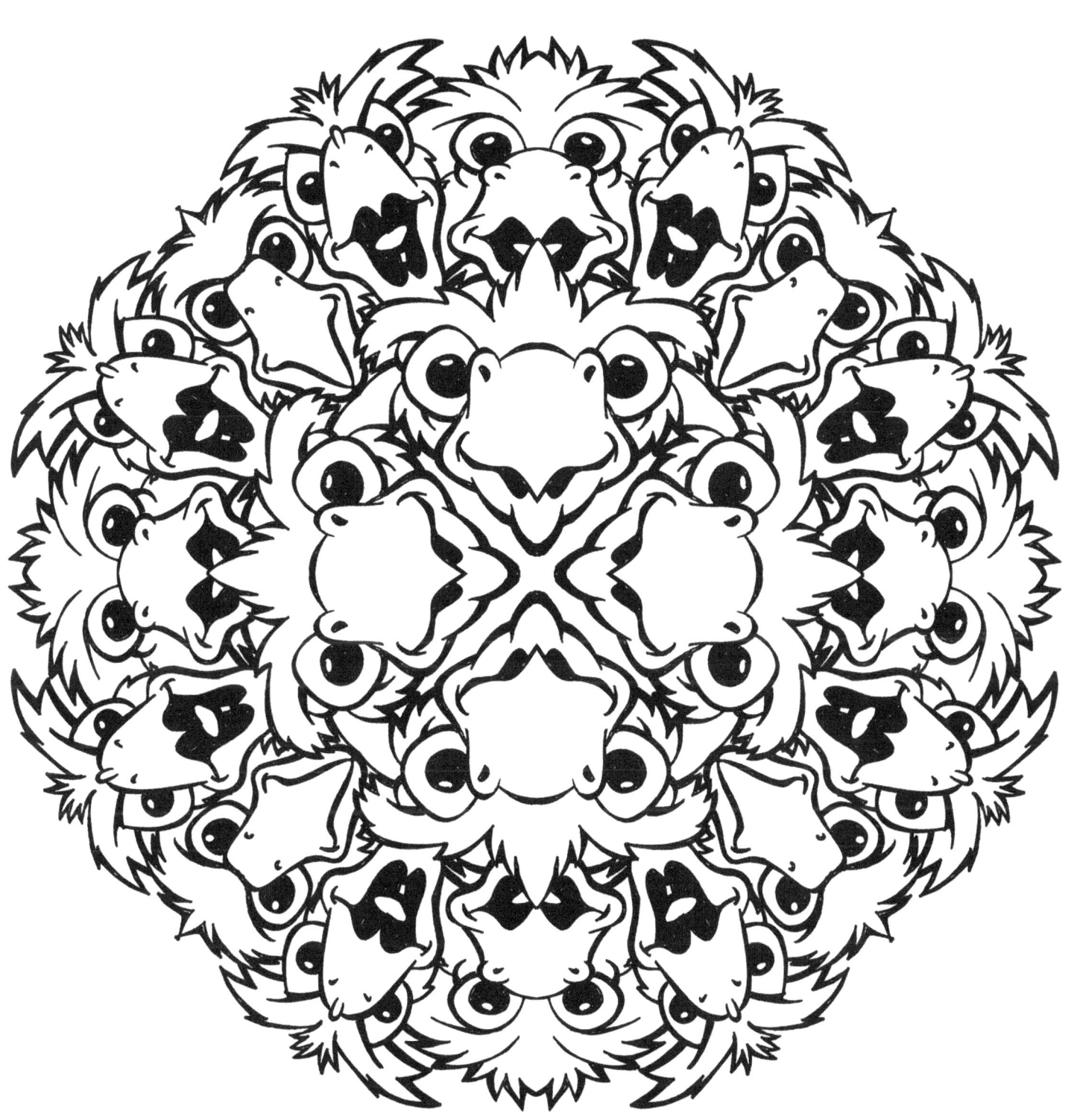

Kaleidoscopic Creatures Book 2
"Cardinals and Co."

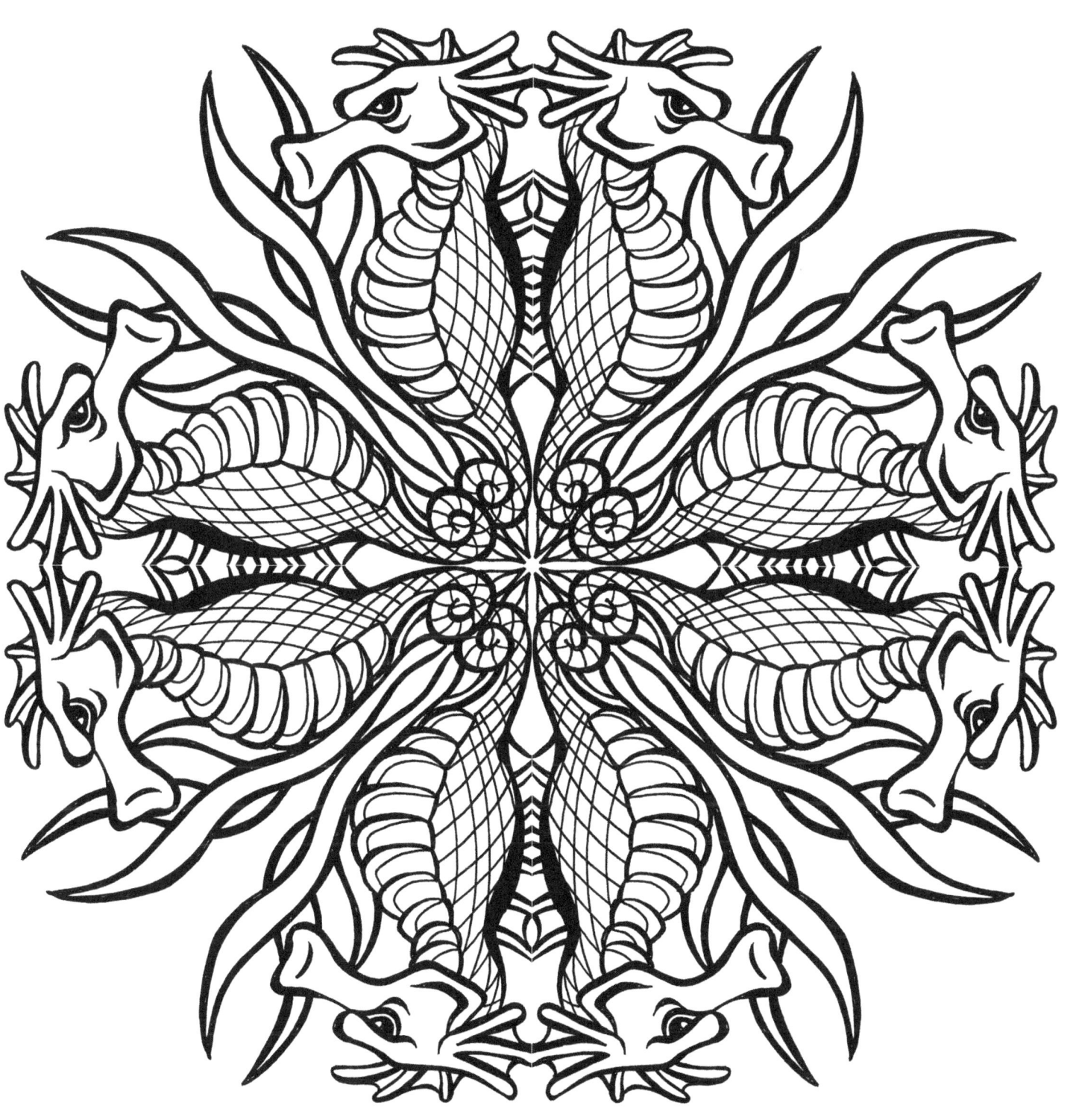

Kaleidoscopic Creatures Book 2
"Seahorse Circle"

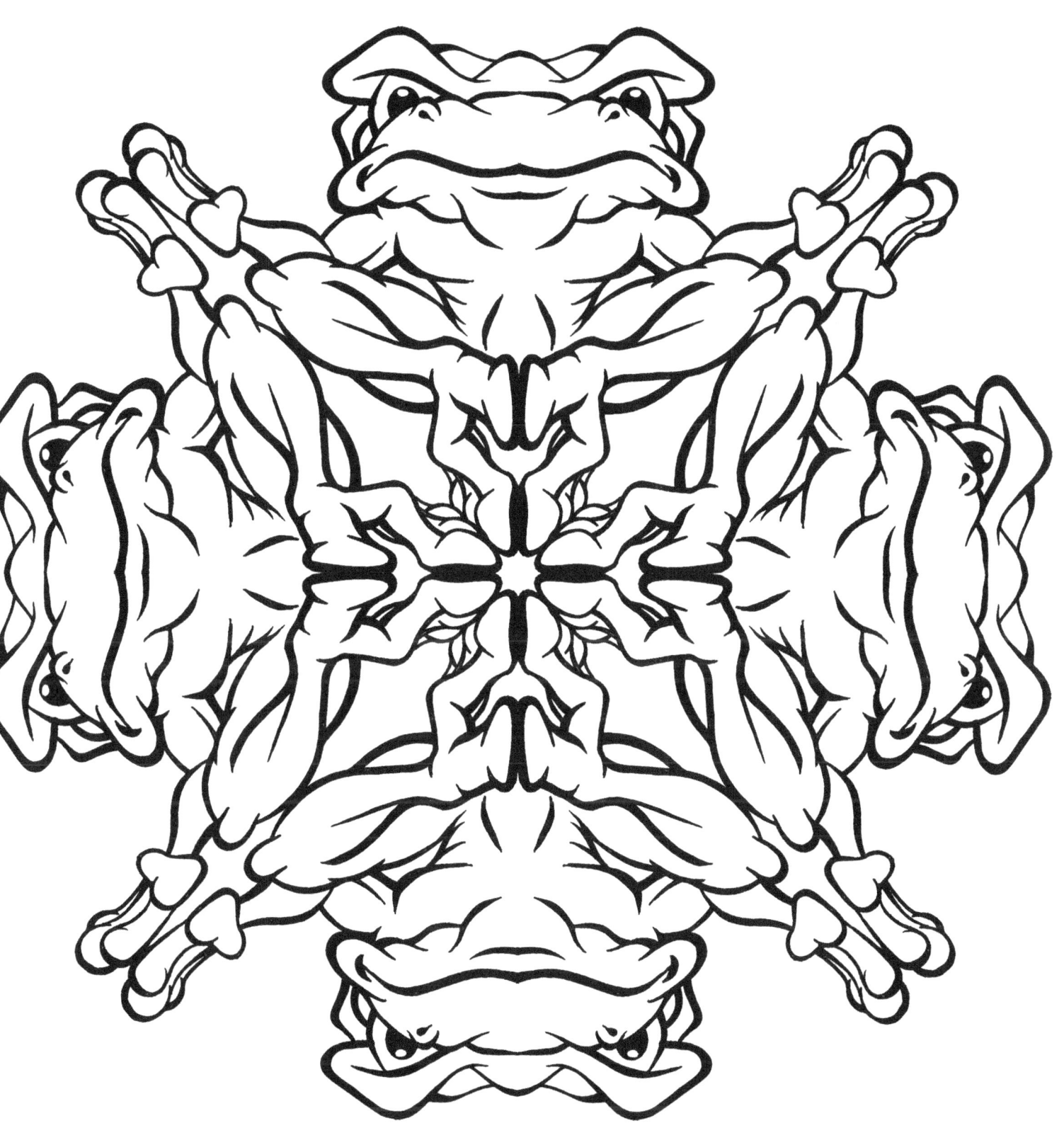

Kaleidoscopic Creatures Book 2
"Ninja Frog"

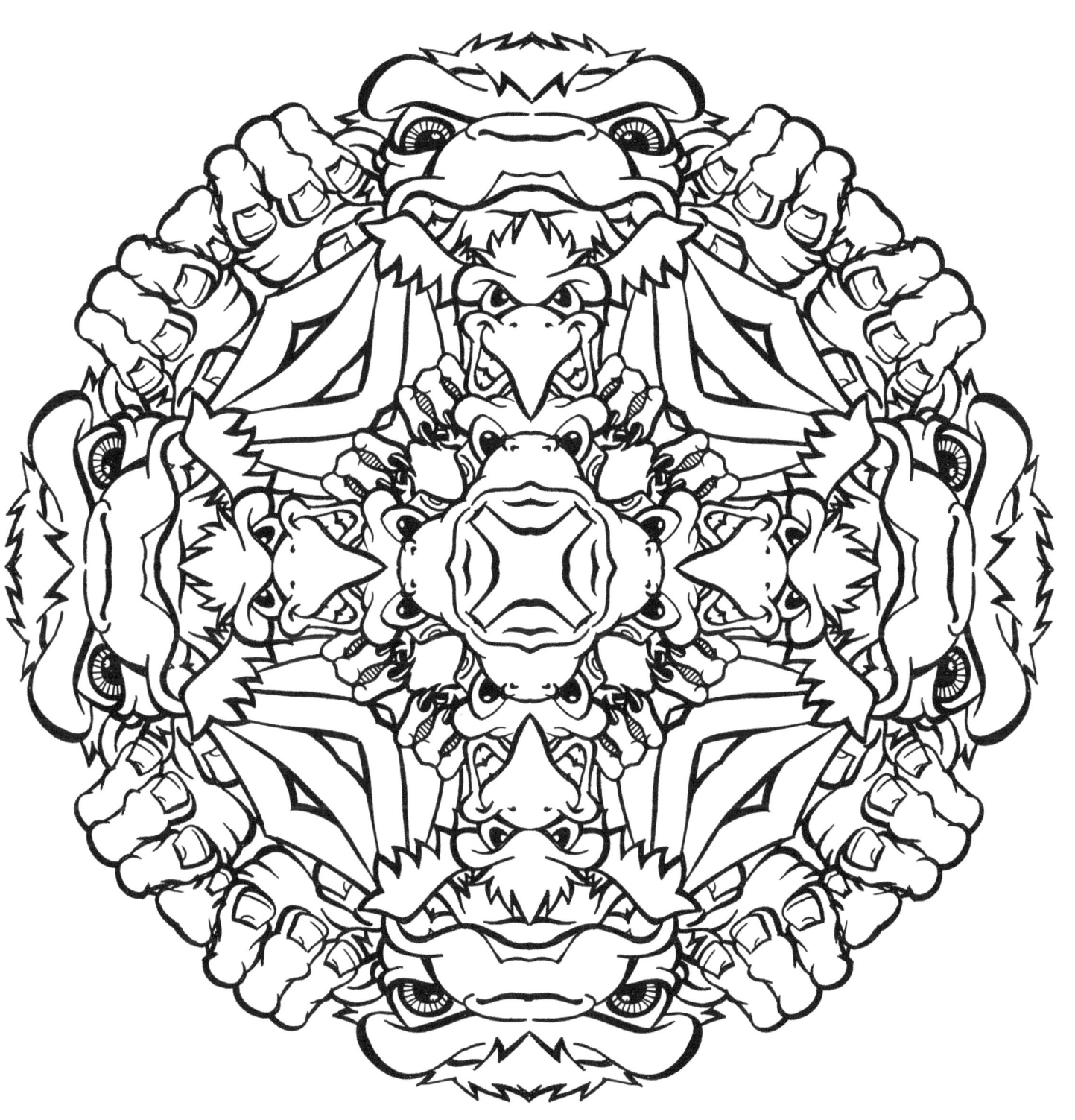

Kaleidoscopic Creatures Book 2
"Food Chain"

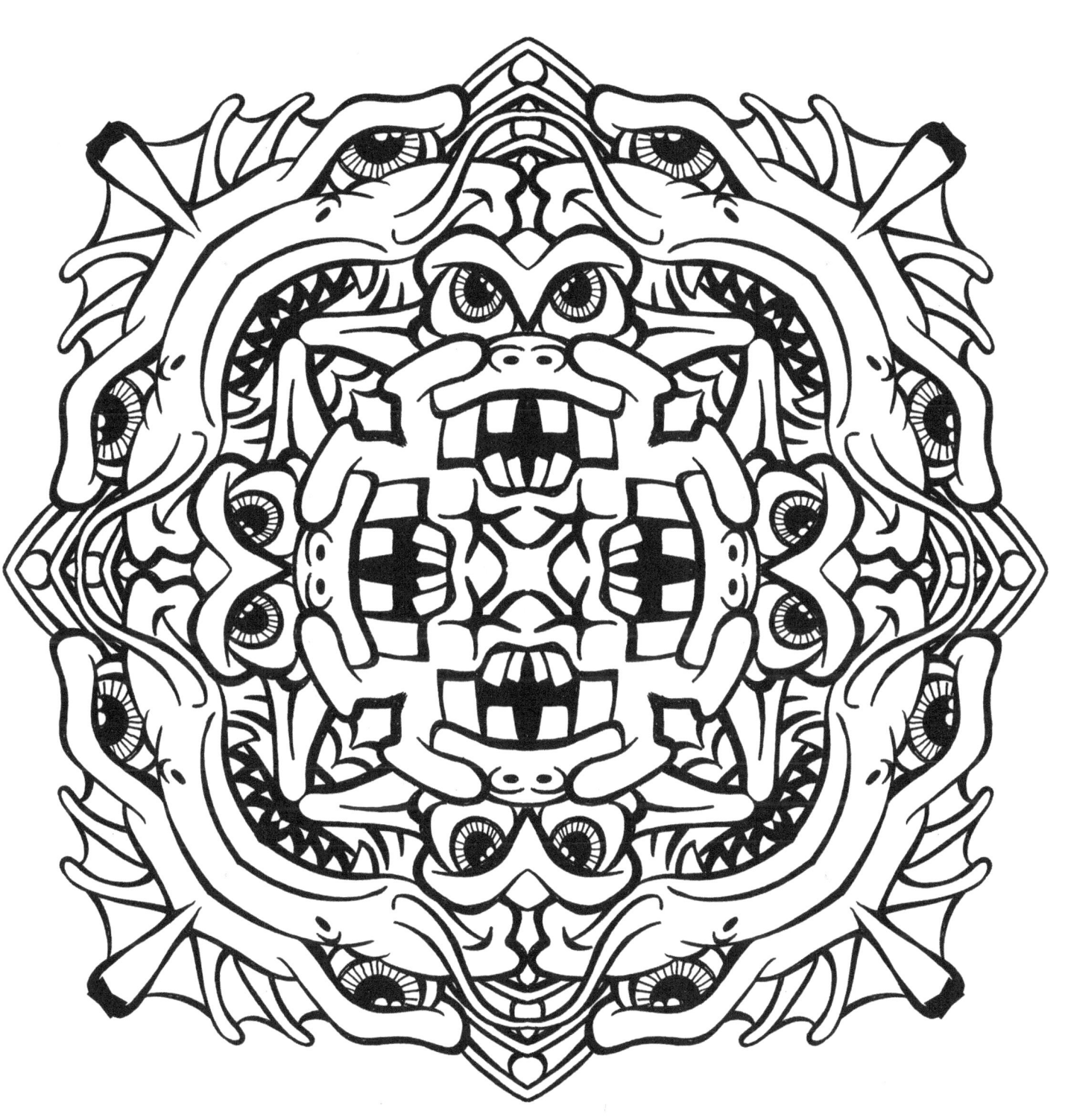

Kaleidoscopic Creatures Book 2
"Snargle and Floke"

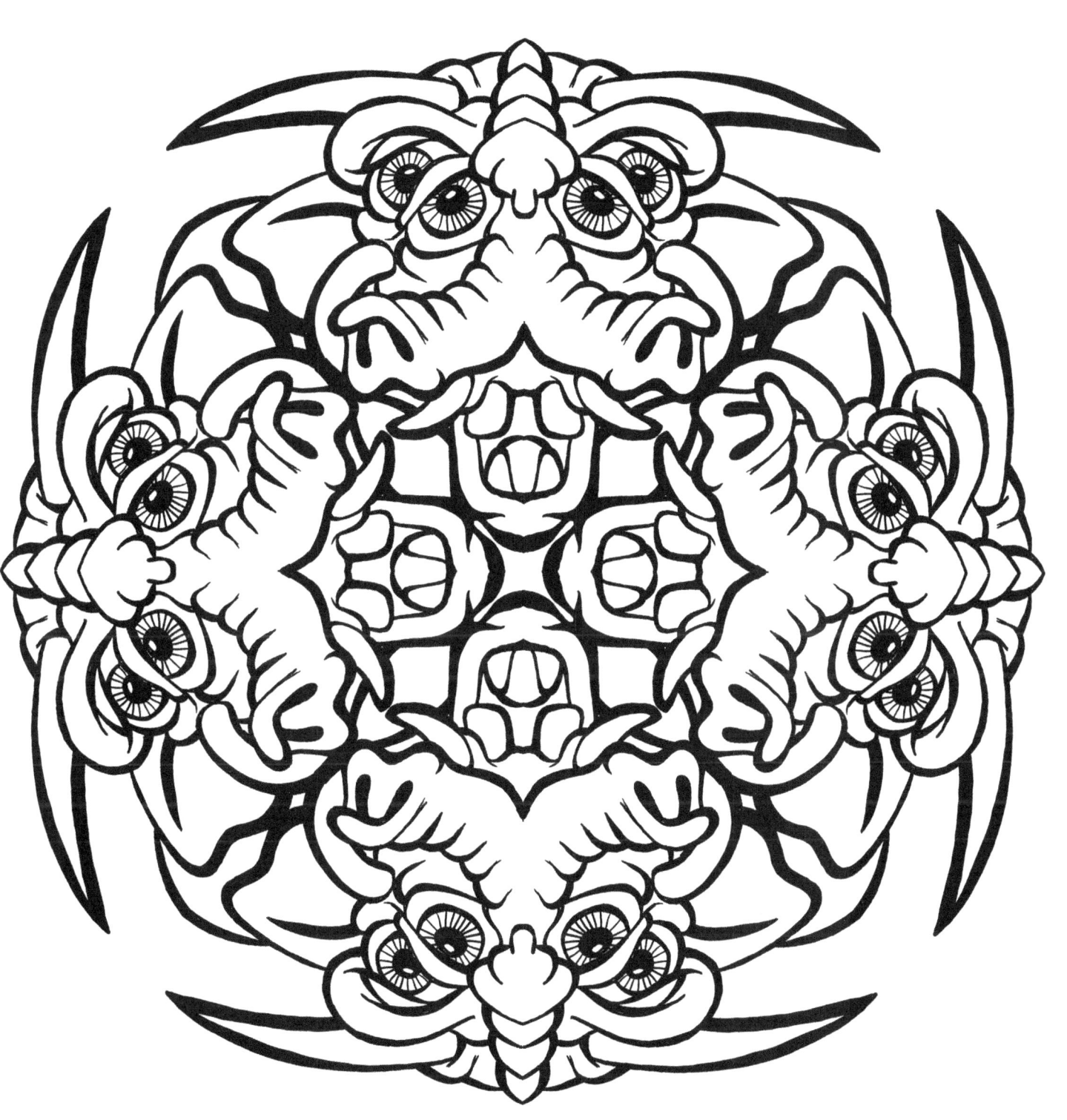

Kaleidoscopic Creatures Book 2
"Doublephant"

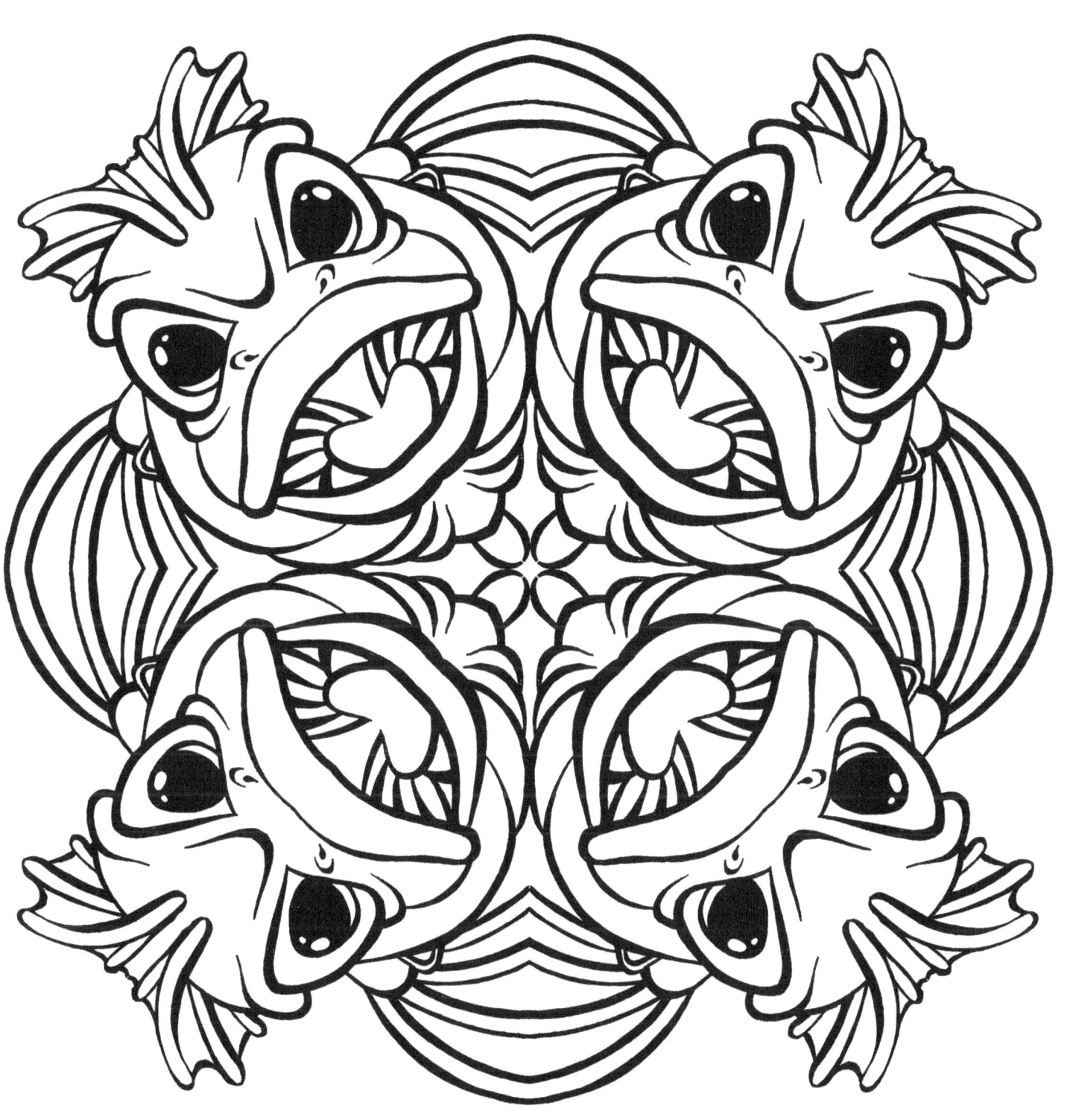

Kaleidoscopic Creatures Book 2
"Fun Fish"

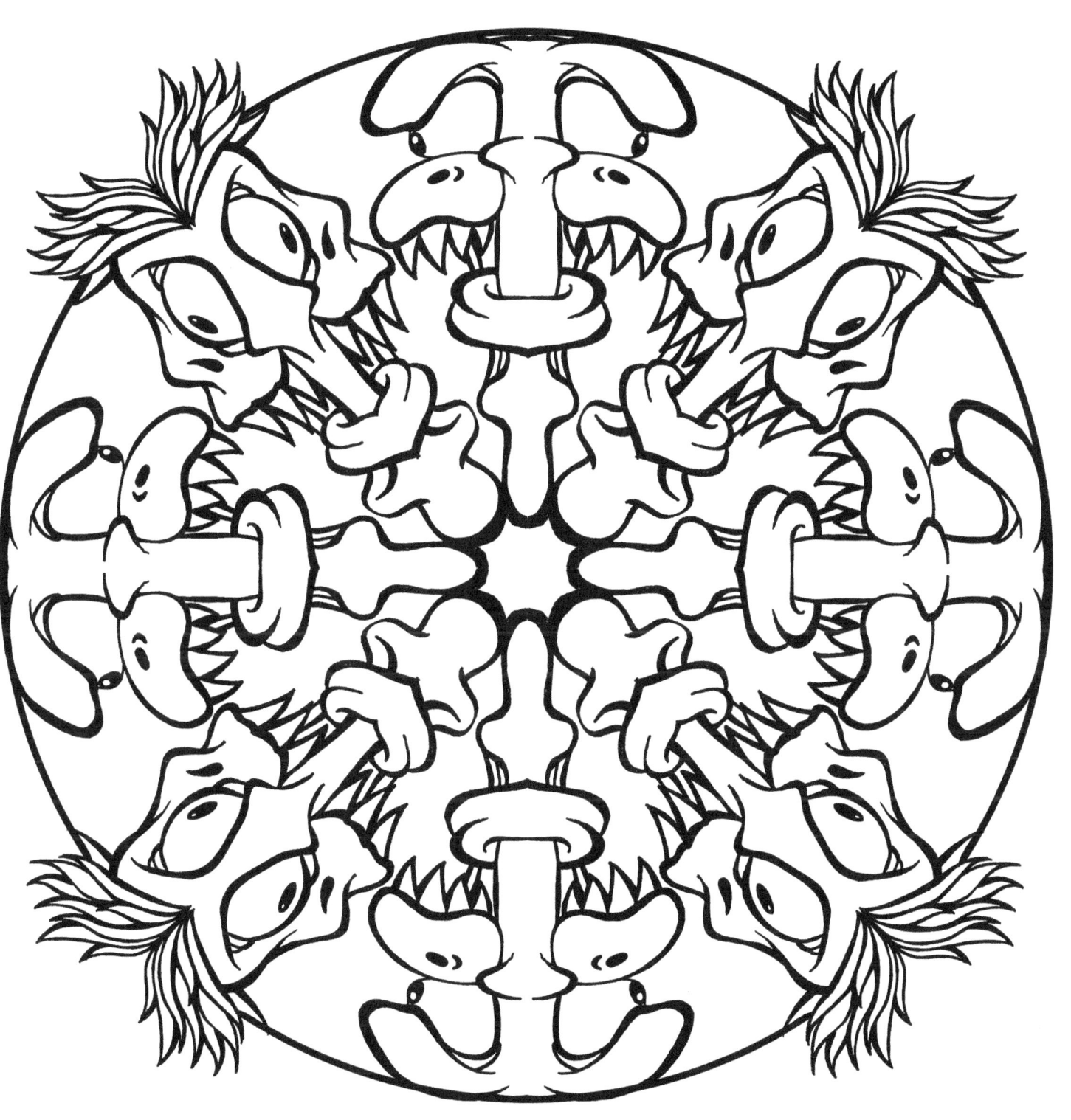

Kaleidoscopic Creatures Book 2
"Tongue Tied"

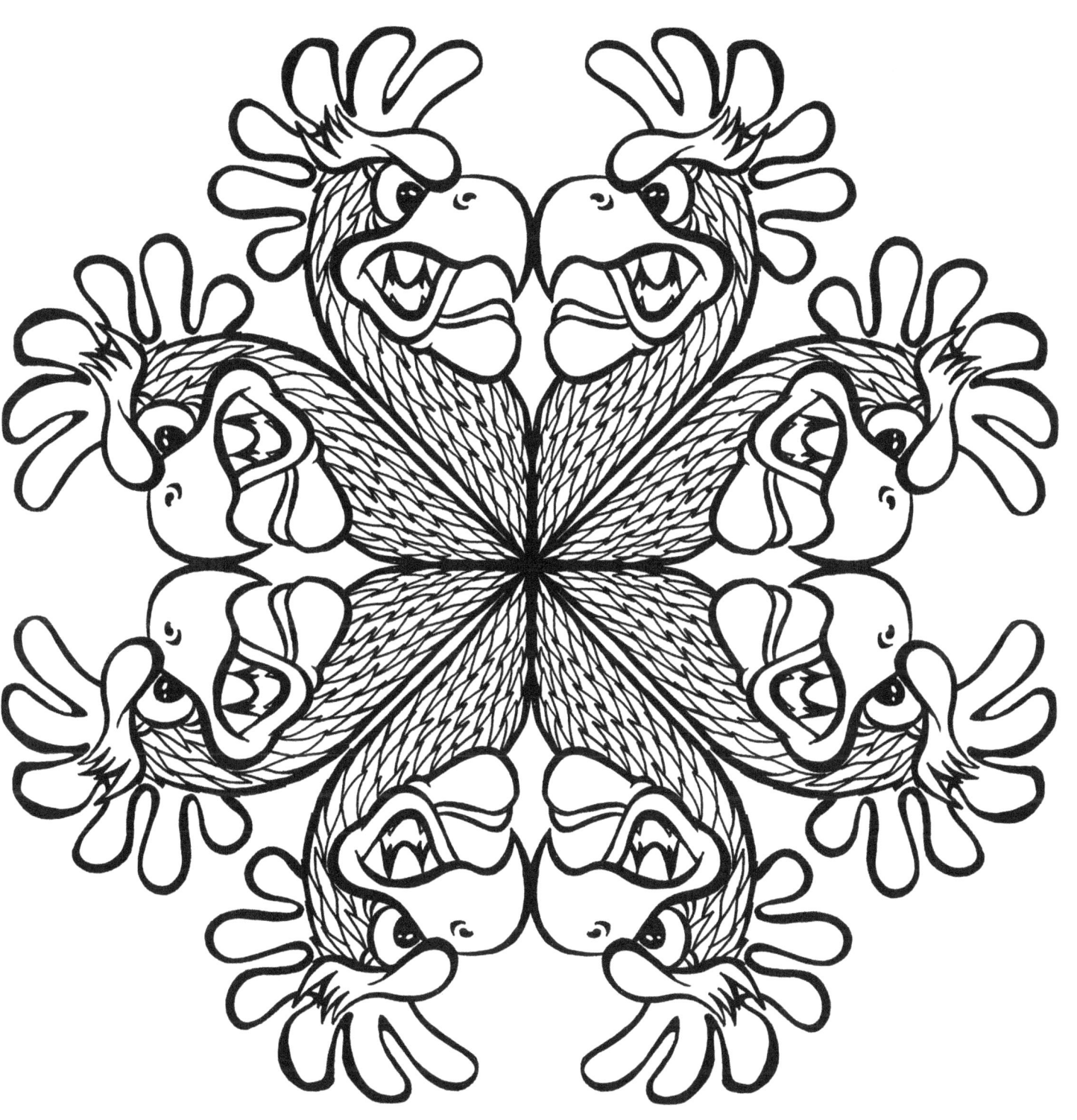

Kaleidoscopic Creatures Book 2
"Rooster's Revenge"

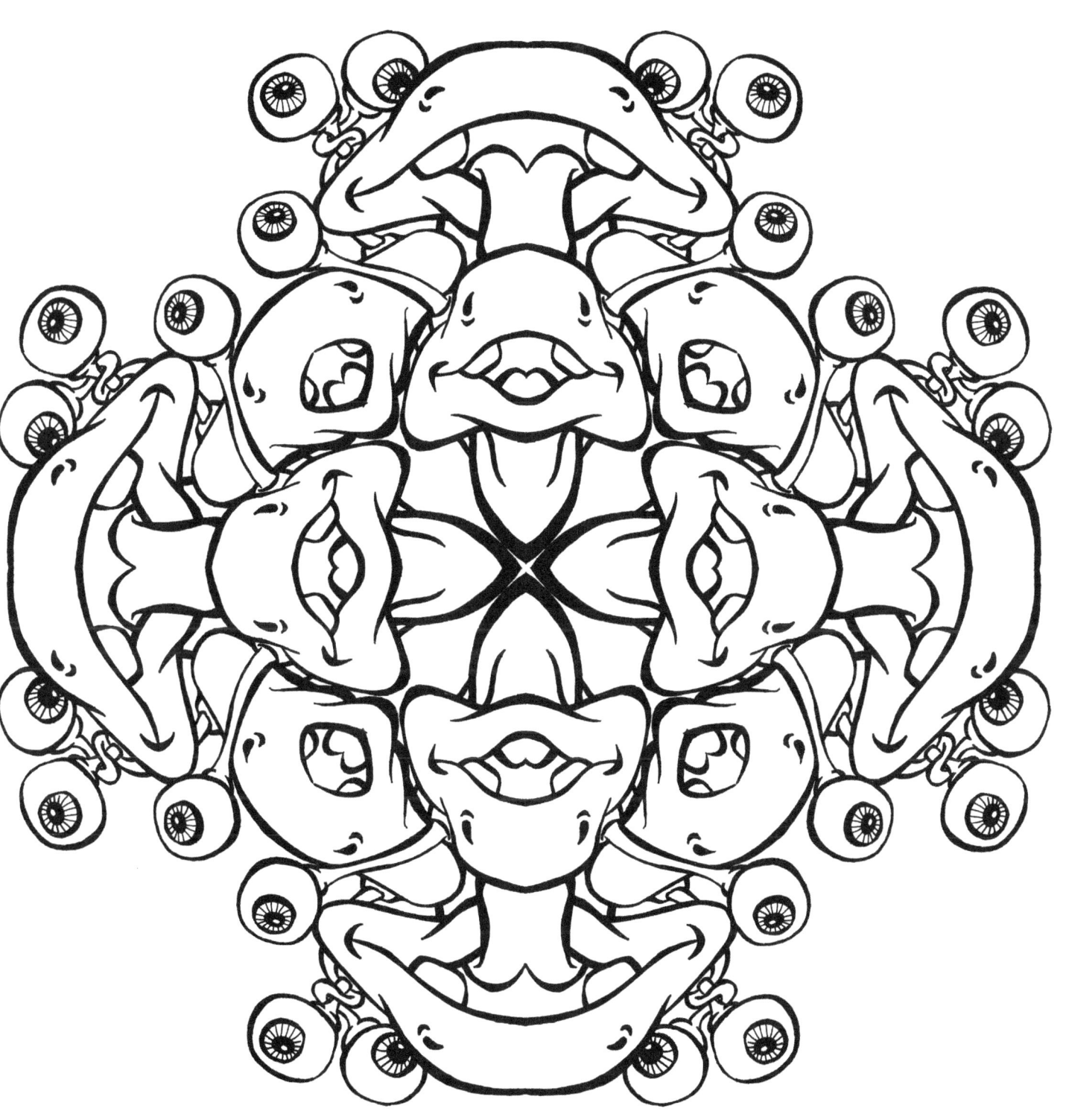

Kaleidoscopic Creatures Book 2
"Slugs"

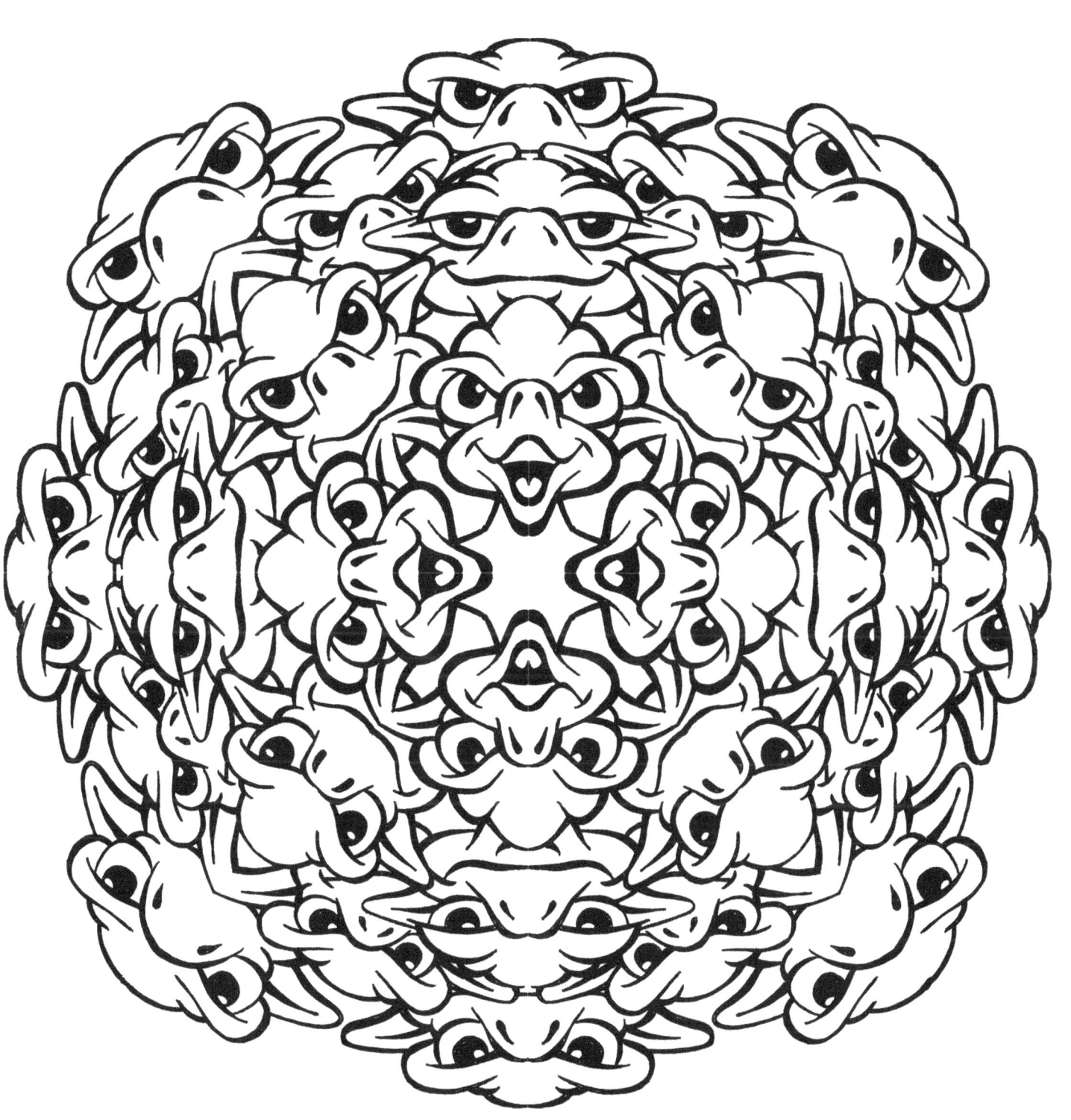

Kaleidoscopic Creatures Book 2
"Floogles"

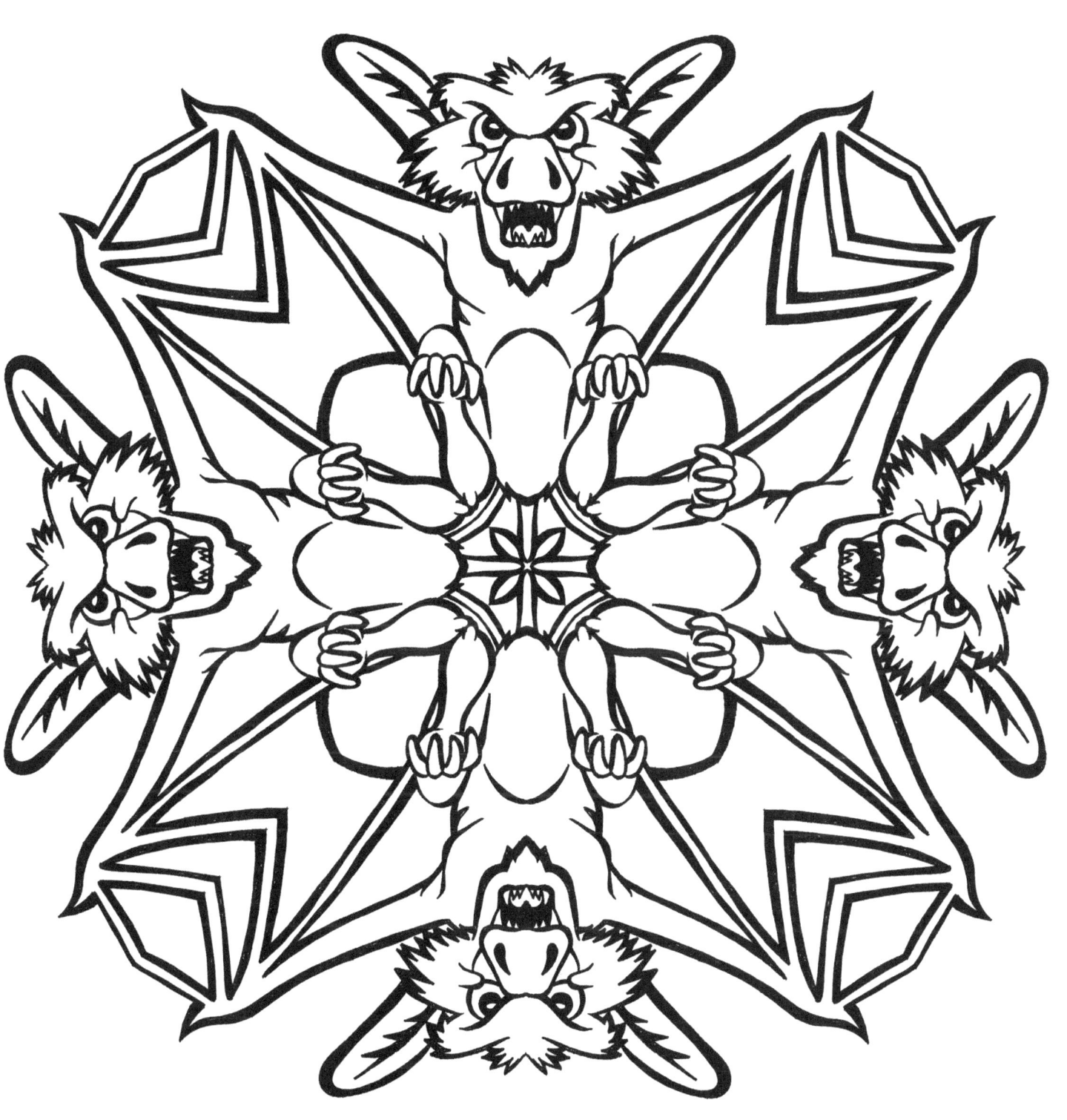

Kaleidoscopic Creatures Book 2
"Gone Batty"

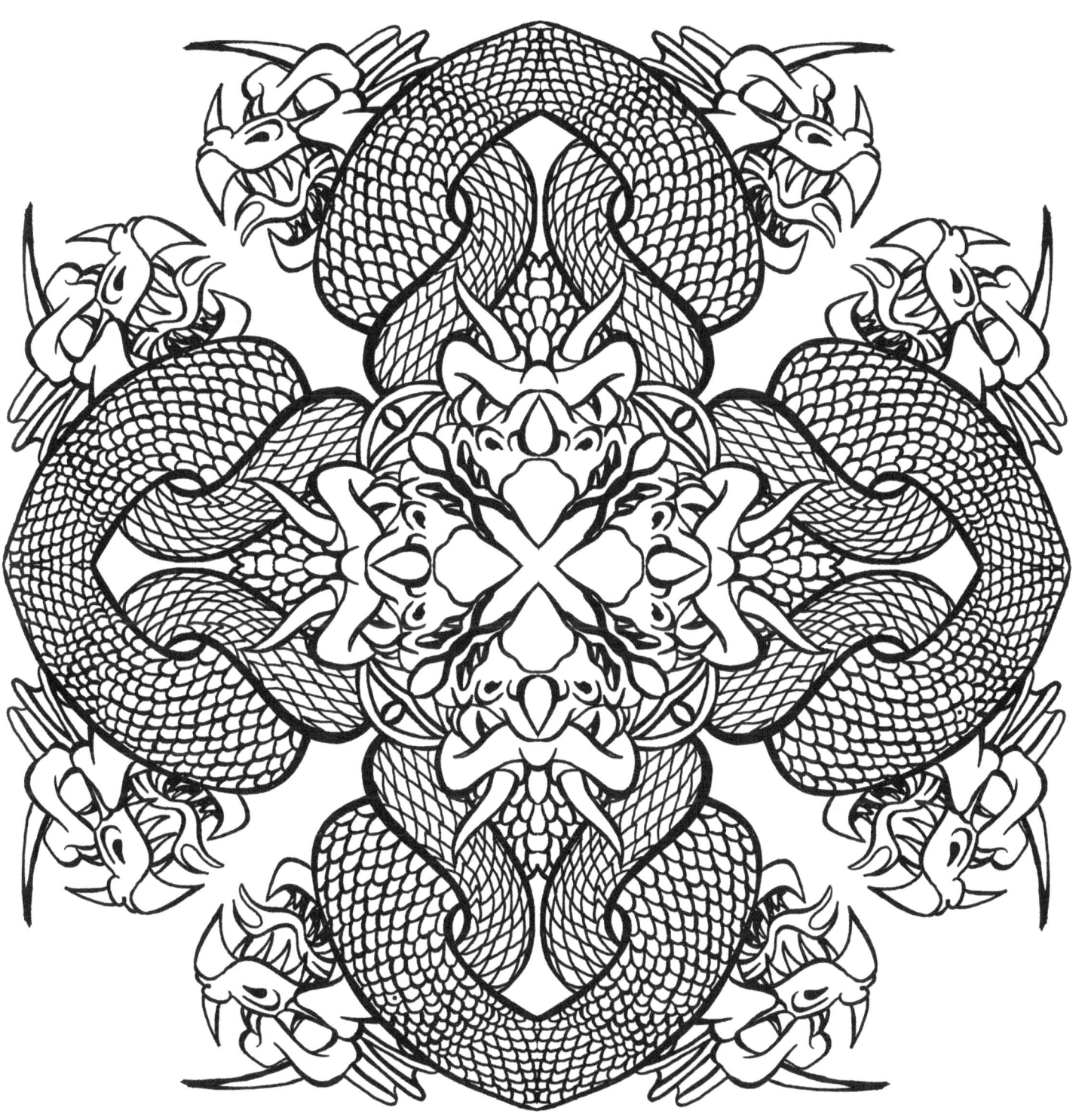

Kaleidoscopic Creatures Book 2
"Sea Serpents"

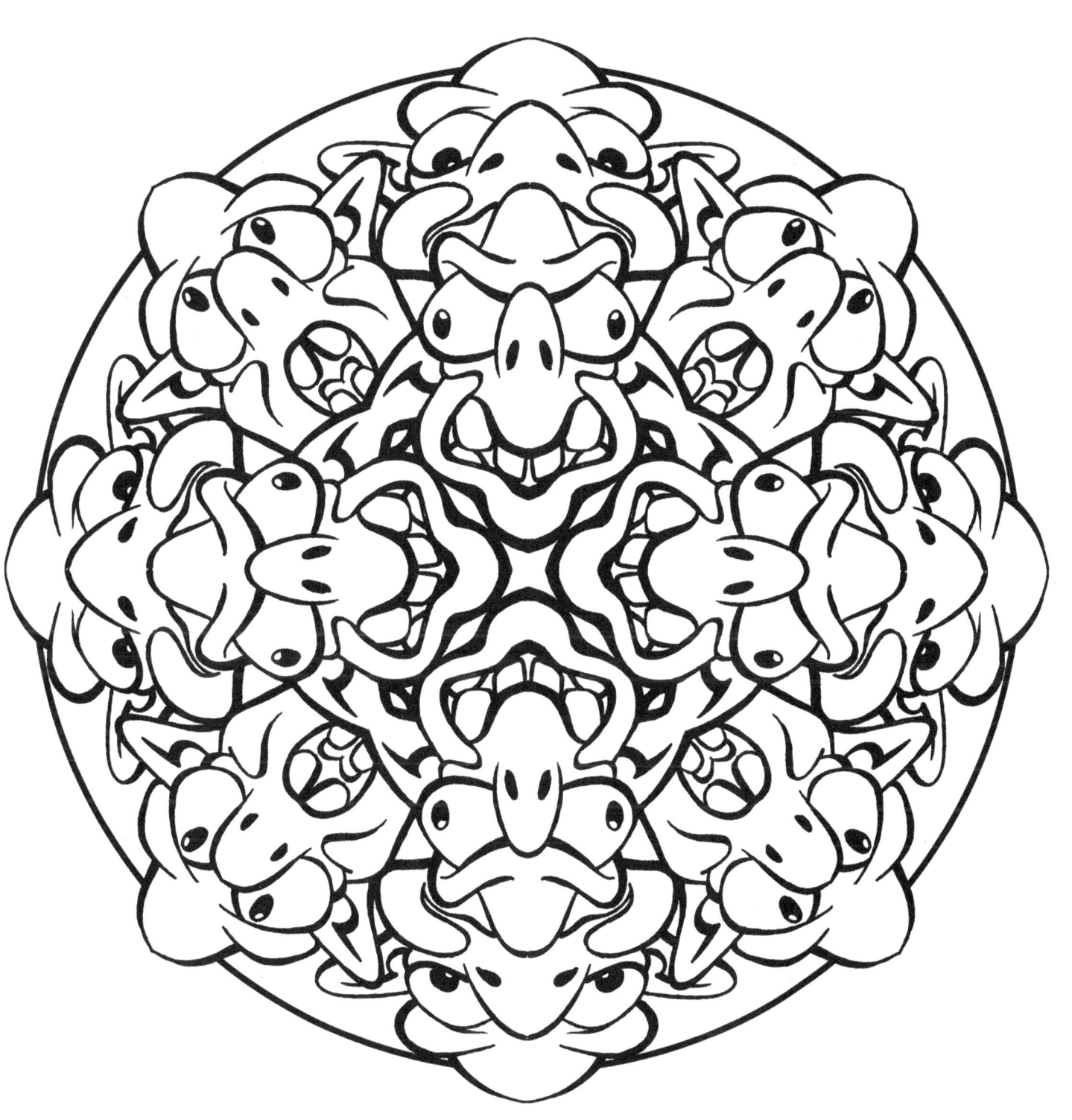

Kaleidoscopic Creatures Book 2
"Trolls, Trolls, Trolls"

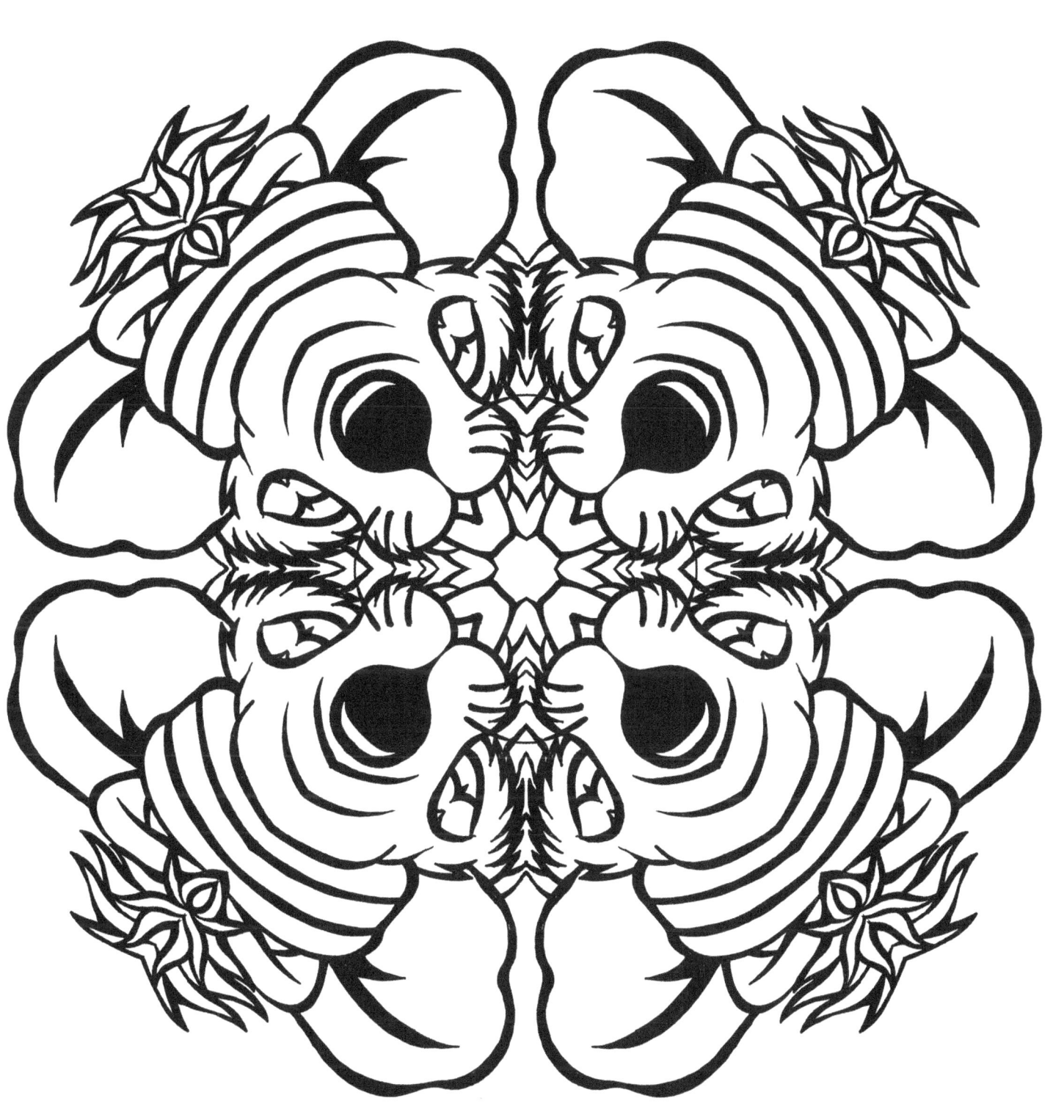

Kaleidoscopic Creatures Book 2
"PunkRats"

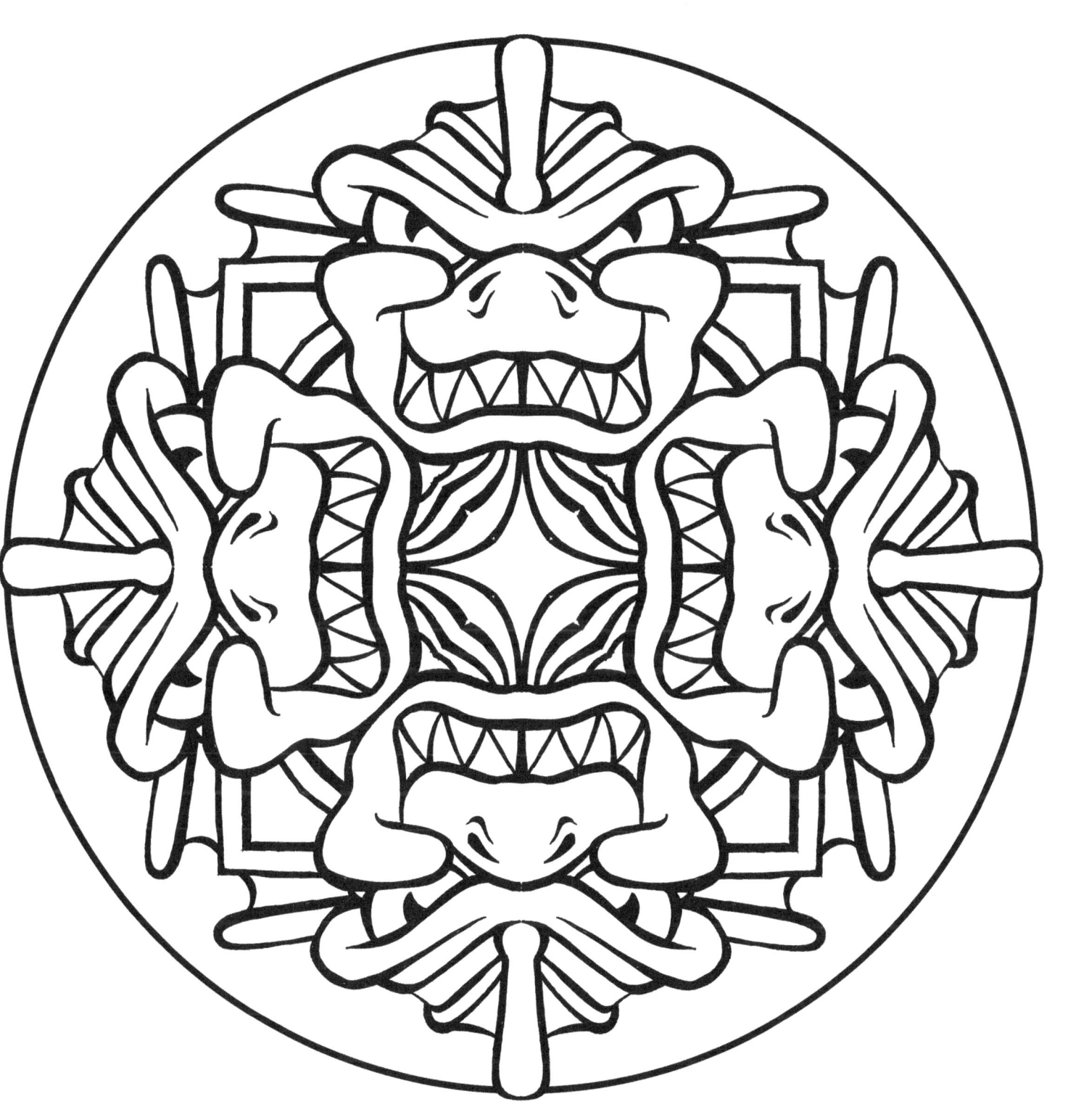

Kaleidoscopic Creatures Book 2
"Lagoonies"

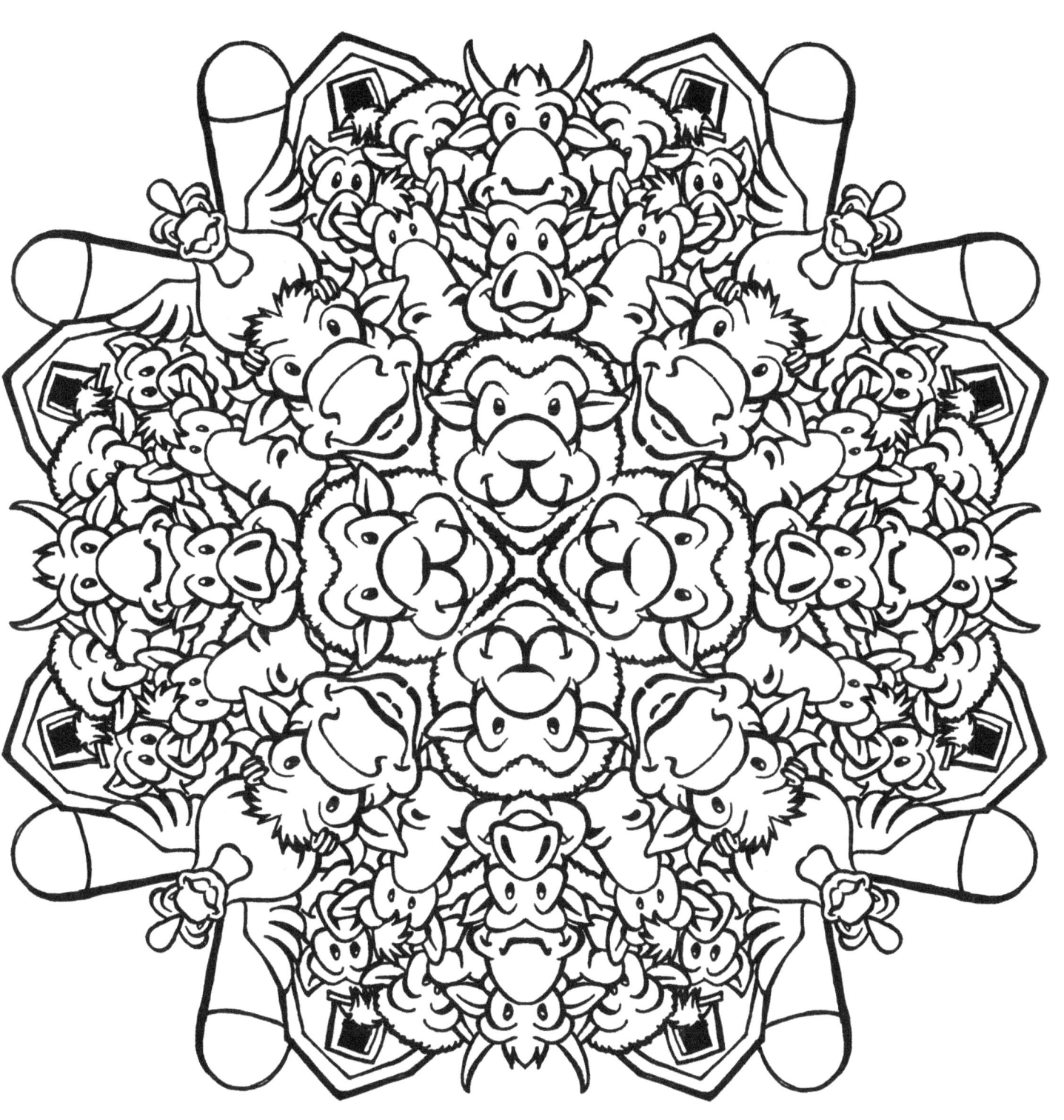

Kaleidoscopic Creatures Book 2
"Down on the Farm"

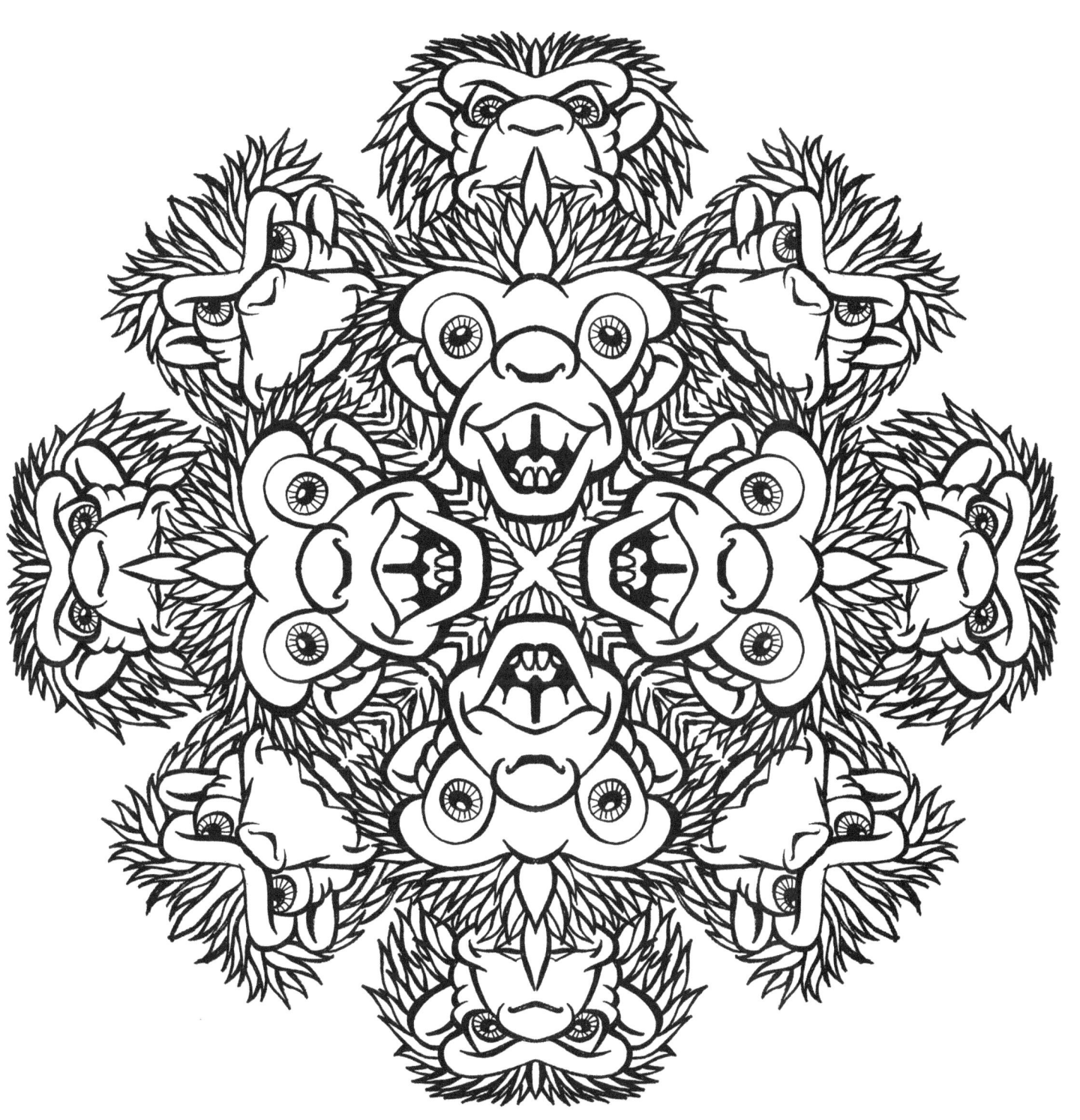

Kaleidoscopic Creatures Book 2
"Hairy Apes"

www.ingramcontent.com/pod-product-compliance
Lightning Source LLC
Chambersburg PA
CBHW080710190526
45169CB00006B/2320